STUART DAVIS

GRAPHIC WORK AND RELATED PAINTINGS

WITH A CATALOGUE RAISONNÉ

OF THE PRINTS

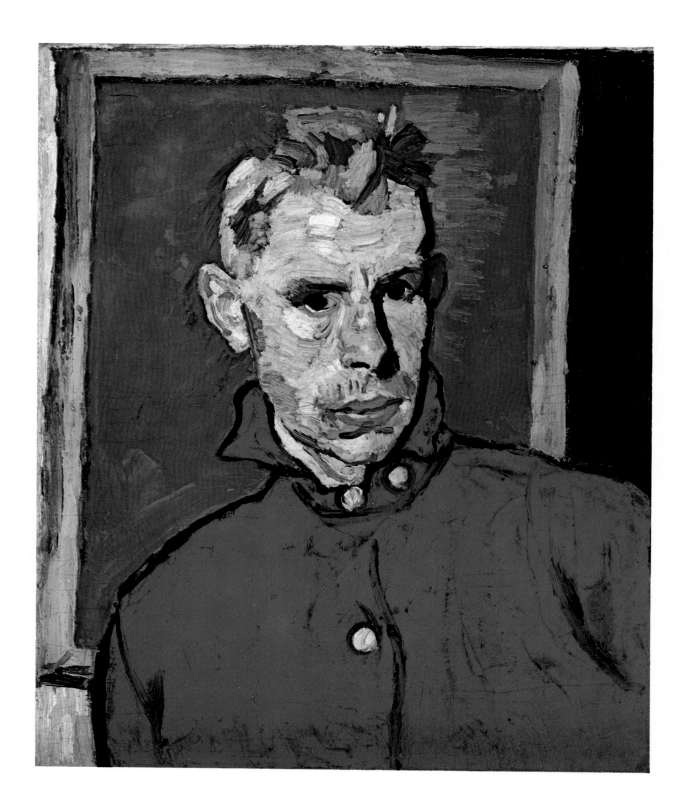

STUART DAVIS

GRAPHIC WORK AND RELATED PAINTINGS WITH
A CATALOGUE RAISONNÉ OF THE PRINTS

Edited by Jane Myers · Essay by Diane Kelder

Catalogue Raisonné by Sylvan Cole and Jane Myers

AMON CARTER MUSEUM

FORT WORTH, TEXAS 1986

Amon Carter Museum

The Amon Carter Museum was established in 1961 under the will of the late Amon G. Carter for the study and documentation of westering North America. The program of the museum, expressed in permanent collections, exhibitions, publications, and special events, reflects many aspects of American culture, both historic and contemporary.

Published on the occasion of the exhibition:

"Stuart Davis: Graphic Work and Related Paintings"
August 29–October 26, 1986

Copyright © 1986 Amon Carter Museum of Western Art, Fort Worth, Texas

All rights reserved

Printed in the United States of America by Hart Graphics, Inc., Austin, Texas

Composed in Linotron Gill Sans by Princeton University Press, Princeton, New Jersey

ISBN 0-88360-054-4
ISBN 0-88360-055-2 (pbk.)
Library of Congress Catalog Card Number 86-70931

Designed by Laury A. Egan

Frontispiece: Stuart Davis, *Self-Portrait*, 1919, oil on canvas, 22¼ × 18¼ in., Amon Carter Museum

CONTENTS

Foreword vii

JAN KEENE MUHLERT

Stuart Davis: Methodology and Imagery I

DIANE KELDER

Stuart Davis: A Catalogue Raisonné of the Prints 17

SYLVAN COLE AND JANE MYERS

 Prints: 1915-1929 23

 Prints: 1931 50

 Prints: 1936-1939 60

 Prints: 1941-1964 72

Exhibition Checklist 80

Selections from Davis's Notebooks and
Sketchbooks, 1922-1938 83

The Prints of Stuart Davis: A Selected
Bibliography 90

Index 93

FOREWORD

THE IMPETUS for this exhibition and catalogue was the Amon Carter Museum's acquisition in 1984 of twenty-six lithographs and serigraphs and a group of seventeen drawings by Stuart Davis. This body of work provides fascinating insights into the artist's methodology and use of graphic media to reinterpret motifs and to explore new pictorial ideas. The collection further complements the Museum's holdings of early modernist works, including three paintings by Davis: *Self-Portrait* (1919), *New Mexican Landscape* (1923), and *Blips and Ifs* (1963-1964). Publication of this material also affords the opportunity to reprint a selection of Davis's trenchant writings compiled by Diane Kelder from the artist's notebooks and first published in 1971 (*Stuart Davis: A Documentary Monograph*. New York, Washington, and London: Praeger Publishers).

In conducting research on the artist's prints, we were most fortunate to have the constant support and counsel of Sylvan Cole. For a number of years he has been assembling important data on Davis's prints in preparation for a catalogue raisonné, which we are pleased to be able to include in this publication. We are indebted to Diane Kelder for providing her thoughtful and illuminating essay, in addition to serving as an advisor for the entire project. Very special thanks are due to Jane Myers, who pursued additional research and diligently coordinated the production of this publication and the organization of the exhibition. Her contributions have been invaluable. We would also like to extend our appreciation to the directors of the Stuart Davis catalogue raisonné project at Salander-O'Reilly Galleries; William C. Agee, editor, Simone Kaplan, Bill O'Reilly, and Larry Salander made this important resource readily available to us. We also thank Earl Davis for his assistance in the preparation of this catalogue and Roselle Davis for her support.

The exhibition and this publication have been enhanced by the generosity of a number of institutions, for which we are most grateful. Paintings related to the Amon Carter Museum's Stuart Davis collection of prints and drawings were lent by the Solomon R. Guggenheim Museum; Herbert F. Johnson Museum of Art, Cornell University; Hirshhorn Museum and Sculpture Garden, Smithsonian Institution; National Museum of American Art, Smithsonian Institution; The Phillips Collection, Washington, D.C.; Portland Museum of Art, Portland, Maine; Wadsworth Atheneum, Hartford, Connecticut; Whitney Museum of American Art; and Roland P. Murdock Collection, Wichita Art Museum.

Staff members at the Amon Carter Museum gave crucial support to the realization of this project. We would especially like to thank Linda Ayres, curator of paintings

and sculpture, for her sound advice in all aspects of the exhibition and publication, and Ron Tyler, assistant director for collections and programs, for his supervision of the catalogue production. Milan Hughston, associate librarian, fielded numerous research questions. Anne Adams and Melissa Thompson assisted in the cataloguing and measuring of the prints and drawings. Our thanks also to Kathie Bennewitz, research assistant, for her contributions to the research on Davis's Paris lithographs, and to Sandy Scheibe for her capable secretarial assistance.

We wish to thank Mr. and Mrs. J. H. Motes for their enthusiastic explorations through Paris in search of subjects that inspired Davis's prints. In addition we gratefully acknowledge the following individuals for generously sharing their expertise on Stuart Davis and American printmaking: Clinton Adams, Tamarind Institute, Albuquerque, New Mexico; Jonathan Bober, Fogg Art Museum, Harvard University; Gertrude Dennis, Weyhe Gallery; Jim Fisher, Fort Worth Art Museum; Bess Fleisher; Janet Flint, Hirschl & Adler Galleries; Elizabeth H. Hawkes, Delaware Art Museum; Sinclair H. Hitchings, Boston Public Library; Lewis Kachur; Jacob Kainen; David Kiehl, The Metropolitan Museum of Art; John R. Lane, Museum of Art, Carnegie Institute; Elizabeth McClintock, Wadsworth Atheneum; Rodney Nevitt, Fogg Art Museum, Harvard University; Martha Oaks, Cape Ann Historical Association, Gloucester, Massachusetts; Elizabeth Olds; Heidi D. Shafranek, Whitney Museum of American Art; Arnold Singer, Cornell University; Mrs. Helen Farr Sloan; Andrew Stasik, Pratt Graphics Center, New York; Samuel J. Wagstaff, Jr.; and Helena Wright, National Museum of American History, Smithsonian Institution. We would also like to thank Laury Egan who designed this handsome publication.

JAN KEENE MUHLERT

STUART DAVIS: METHODOLOGY AND IMAGERY

MORE THAN any other twentieth-century American artist Stuart Davis (1892-1964) was a vigorous and articulate champion of modernism. His distinguished career spanned nearly sixty years and two world wars; it saw the realism that nurtured him give way to the challenge of European avant-garde art in the years following the Armory Show of 1913, only to resurface during the climate of political and cultural isolationism that prevailed in the Depression years. During that period of unrelenting hostility to abstract painting Davis never ceased to reiterate his conviction that a "picture [was] an independent object with a reality of its own."[1] Hardly a fashionable or popular painter in the years when abstraction was regarded as un-American, Davis found himself once again isolated from the groundswell of abstract expressionism that surfaced in the late 1940s and dominated the 1950s. Yet throughout, he maintained an independent stance—responsive to the aesthetic issues raised by pioneering European modernists, but determined to reconcile them with the partic-

ular experience and quality of American life—insisting to the end that he was both a modernist and a realist.

Early in his career Davis initiated a process of self-interrogation whose objective was the establishment and clarification of aesthetic principles that were tested, amplified, refined, and synthesized over the years. This process took the form of extensive writings in journals and sketchbooks that were often accompanied by drawings and diagrams. Not only do these writings document the artistic and intellectual growth of one of America's most original modern masters, they provide an invaluable insight into his method of painting. In his catalogue essay for the 1978 Brooklyn Museum exhibition, John Lane argued convincingly that while the writings and sketches are crucial to our understanding of the form and the content of Davis's paintings, they also offer a unique perspective on the vital aesthetic, social, and political issues that informed American painting in its critical period of maturation.

Born in Philadelphia in 1892, Davis grew up in a home in which art was part of daily experience. His mother, Helen Stuart Foulke, was a sculptor and his father, Edward Wyatt Davis, was art editor of the *Philadelphia Press*. The

[1] "How to Construct a Modern Easel Picture," a lecture delivered by Stuart Davis at the New School for Social Research on December 17, 1941.

senior Davis was friendly with some of the most contro-versial painters of the period, including Robert Henri and his disciples, William Glackens, John Sloan, George Luks, and Everett Shinn, who would later constitute the nucleus of the group called "The Eight." In 1909, eight years after his family moved to East Orange, New Jersey, Davis per-suaded his father to let him leave high school in order to pursue his art studies full time. He enrolled in Henri's school in New York and remained there for three years. In a letter to his cousin Hazel Foulke, who was studying at the Pennsylvania Academy of the Fine Arts, he stated, "Henri's is different than any other school in the world, and if he should stop I would never go to any other teacher because the rest of them don't know what real drawing is. . . ."[2] Rejecting academic rules and conventional notions of beauty, the Henri approach emphasized free-dom of expression and encouraged students to look for subjects in the world around them. Later, this cultivated sensitivity to the contemporary world enabled Davis to transcribe the visual dynamics of Manhattan streets or New England seaports into an abstract plastic language without sacrificing the topical character of the initial stimulus.

Henri's admonition "to place the origins of art in life" contributed significantly to the development of a socially conscious art. Following in the footsteps of other Henri students, Davis roamed the streets of Chinatown and the Bowery, frequenting burlesque houses and dance halls in search of themes that expressed the energy of urban life. Indeed, Davis's demonstrable capacity to portray "life in the raw" prompted John Sloan, who was then art editor of the radical socialist magazine *The Masses*, to invite him to join the staff as an illustrator. He remained for three years, resigning in protest when its editor-in-chief at-tempted to impose a more forceful social and political orientation on its contributors. Though acutely aware of the didactic and social function of art, Davis never

[2] Letter of February 22, 1913, quoted in John R. Lane, *Stuart Davis: Art and Art Theory*, exh. cat. (New York: The Brooklyn Museum, 1978), p. 9.

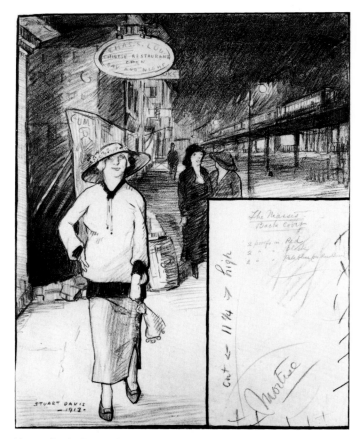

Masses Back Cover, 1913
Crayon on paper, 22¼ x 17⅜ in., Collection of Earl Davis

swerved from his belief that artistic integrity should not be subordinated to political expediency.

Although vestiges of realism would permeate Davis's work for some time, his artistic formation was radically altered by the International Exhibition of Modern Art, popularly known as the Armory Show, which opened in New York in 1913. Organized by artists and amateurs rather than by academicians, the exhibition proclaimed their goal of exposing their colleagues and the general public to the work of European modernists. For Davis,

who exhibited five watercolors, the Armory Show was a revelation. In a letter to his cousin written just five days after the historic opening, he singled out the contributions of Gauguin, Matisse, Picasso, and Picabia, reserving special praise for Cézanne and Van Gogh. Years later, he recalled his excitement at confronting "broad generalization of form and non-imitative use of color" and in perceiving ". . . an objective order in these works which I felt was lacking in my own. . . ." He resolved that he "would quite definitely have to become a modern artist."[3]

The Armory Show generated a period of introspection that made Davis aware of the shortcomings of his artistic training. He subsequently criticized his former teacher for having placed undue emphasis on subject matter at the expense of methodology, recognizing that Henri's repudiation of academic formulae was not accompanied by the assertion of new formal principles. He complained that "the borderline between descriptive and illustrative painting, and art as an autonomous sensate object was never clarified."[4]

Davis's resolve to become a modern artist did not result in immediate stylistic transformation. It would be four years before he broke definitively with the Ashcan School realism that had marked his earlier work. In paintings executed between 1915 and 1918, he made a conscious effort to emulate the simplified forms and expressive color of the postimpressionist and fauvist canvases he had admired in the Armory Show. The influence of Van Gogh is felt especially in his landscapes and in the high key colors and generous pigmentation of his 1919 self-portrait (frontispiece). Although Davis had approvingly chronicled the presence of cubists and futurists in the 1913 exhibition, his initial response to the former was tentative. In the remarkable canvases *Breakfast Table* (c. 1917, private collection) and *The President* (1917, Munson-Williams-Proctor Institute), he experimented with grid-like compositions

Multiple Views, 1918
Oil on canvas, 47¼ x 35¼ in., Collection of Earl Davis

and faceted color planes that are reminiscent of analytic cubism, but these works were essentially isolated efforts.

In *Multiple Views*, painted in 1918, Davis did not attempt a sophisticated and systematic analysis of form comparable to *The President* or *Breakfast Table*. Instead, he sought to convey diversity of time, place, and atmosphere through a juxtaposition of interior and exterior vignettes similar to those he had employed in a cartoon drawn a

[3] Stuart Davis, *Stuart Davis* (New York: American Artists Group, 1945), unpaginated.
[4] Ibid.

3

year earlier.[5] This appropriation of an early compositional strategy from one medium to another may well represent the first instance of the creative "recycling" that characterized Davis's approach to painting from the late 1920s on. Although *Multiple Views* is an extremely ambitious work, its composition is not completely resolved; the discrepancy between illustrative space and abstract space is disturbing, and despite the artist's efforts to stress the physical reality of the whole painted surface, the various parts do not coalesce. Still the painting is important, for not only does it anticipate Davis's highly successful New York–Paris series of 1930-1931, it provides an insight into a major aspect of his methodology, namely, his capacity to attach a formal or thematic problem in a painting or series of paintings and then put it aside only to explore it again. Referring to this practice in 1952, Davis maintained, "Work on an old picture is as valid as to take a wise statement and increase its mass in the image of experience."[6]

In the early 1920s, when the enthusiasm for cubism engendered in America by the Armory Show had diminished, Davis made a concerted effort to master the techniques of synthetic cubism. As Picasso and Braque had done a decade earlier, he made collages and paintings such as *Lucky Strike, Bull Durham* (1921, The Baltimore Museum of Art), and *Sweet Caporal* (1922, Thyssen-Bornemisza Collection), which simulated collages. When he painted these canvases, Davis was distinctly less concerned with *what* to paint than with *how* to paint it. His contemporaneous journals often assess the achievements of his European predecessors, addressing such problems as nature versus abstraction, fictive versus real space, and the functions of color and drawing. By 1922, Davis had formulated a concept of painting that emphasized procedure and accountability, qualities that remained at the center of his artistic concern for the rest of his life:

[5] Lane, p. 90.
[6] Stuart Davis Papers, Harvard University, Cambridge, Mass., Index, June 17, 1952.

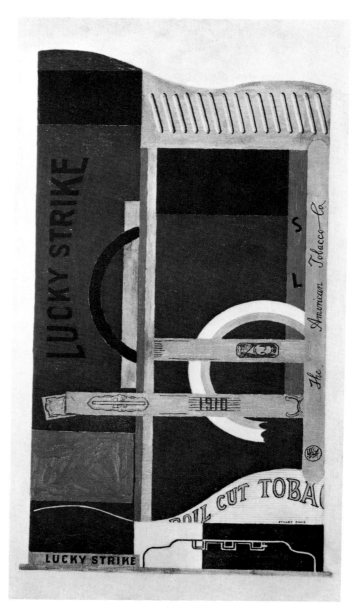

Lucky Strike, 1921
Oil on canvas, 33¼ x 18 in., Collection, The Museum of Modern Art, New York; Gift of The American Tobacco Company, Inc.

A work of art ... should be first of all impersonal in execution.... It may be as simple as you please but the elements that go to make it up must be positive and direct.... The work must be well built.... The subject may be what you please ... but in all cases the medium itself must have its own logic.[7]

The painted collages were the earliest manifestation of a lifelong fascination with the dynamics of modern packaging, which Davis regarded as having positive aesthetic value. At the same time, he stated that he wanted to utilize "letters, numbers, canned good labels, tobacco labels ... purely objective things ... to indicate location and size."[8] This reasoning was consistent with his new emphasis on the two-dimensional physical reality of his canvas.

Despite his strenuous commitment to creating a new synthetic reality, Davis still responded to the immediacy of his environment as witnessed in a series of simplified but directly observed landscape paintings he made during a trip to New Mexico in the summer of 1923. In fact, an attempt to accommodate nature and abstraction would remain one of his fundamental concerns through the 1930s. In the following year, Davis painted a number of works that gave concrete form to his evolving modernism. Seeking "a generalization of form in which the subject was conceived as a series of planes and the planes as geometrical shapes ... arranged in direct relationship to the canvas as a flat surface,"[9] he produced *Odol* (1924, Cincinnati Art Museum) and *Super Table* (1925, Collection of Mr. and Mrs. Rolf Weinberg), compositions that reflect his sensitive absorption of pictorial devices used by Picasso and Leger. This new mode of pictorial construction is well documented in a sketchbook of 1926. As an ad-

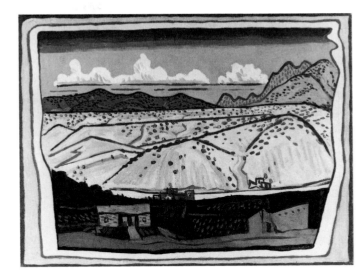

New Mexican Landscape, 1923
Oil on canvas, 32 × 40¼ in., Amon Carter Museum

junct to one of the many drawings of fragmented New York views (subsequently used in paintings and prints of the early 1930s), he offered a practical demonstration of how to convey essential formal and spatial relationships.

The climax of Davis's efforts to master the vocabulary of cubism came in 1927-1928 when, eschewing the traditional French *tableau objet*, he nailed an eggbeater, an electric fan, and a rubber glove to a table and painted them repeatedly. Nearly twenty years later, Davis told James Johnson Sweeney that the subject of the eggbeaters was "an invented series of planes.... They were a bit on the severe side, but the ideas invoked in their construction have continued to serve me.... My aim was not to establish a self-sufficient system to take the place of the immediate and accidental, but to ... strip a subject down to the real physical source of its stimulus ... so you may say that everything I have done since has been based on that eggbeater idea."[10] Davis called the eggbeaters and the

[7] Stuart Davis, Notebook, December 30, 1922. Printed in Diane Kelder, ed., *Stuart Davis: A Documentary Monograph* (New York, Washington, and London: Praeger Publishers, 1971), pp. 33-34.

[8] Davis's journals c. 1920-1922, quoted in Lane, p. 94.

[9] James Johnson Sweeney, *Stuart Davis*, exh. cat. (New York: Museum of Modern Art, 1945), p. 17.

[10] Ibid.

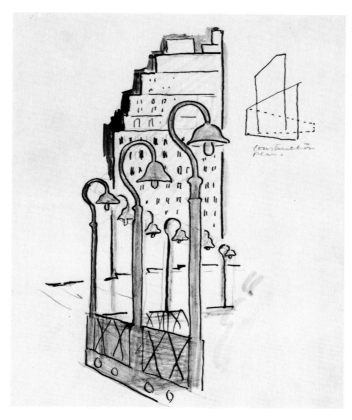

Sketchbook drawing, 1926
Graphite on paper, 6¾ x 8¼ in., Collection of Earl Davis

Eggbeater Number 2, 1927
Oil on canvas, 29 x 36 in., Collection of Whitney Museum of
American Art, New York

percolators and matchbooks that followed them "formula
pictures," asserting that "the formula [could] be arrived at
through . . . observation of nature and intellectual selection
of the common denominator of varieties . . . which [could]
be rationalized and used over and over again with success.
. . ."[11] Decades later, utilizing the compositional matrices of
Eggbeater No. 4 (1927-1928, Collection of Mr. and Mrs.
James A. Fisher) for *Hot Still-Scape for Six Colors—7th Av-
enue Style* (1940, jointly owned by the William H. Lane
Foundation and the Museum of Fine Arts, Boston) and of

[11] Stuart Davis, Notebook, 1932. Printed in Kelder, p. 60.

Percolator (1927, The Metropolitan Museum of Art, New
York) for *Owh! In San Paõ* (1951, Whitney Museum of
American Art), he brilliantly demonstrated the validity of
his theoretical claim.

Until he left for Paris in June 1928, Davis was the only
major American modernist who had no direct experience
with French art. Renting a studio at 50 rue Vercingétorix,
he remained for more than a year. His reaction to this
totally new environment was conveyed in a number of
street scenes in which the structural severity of the
eggbeaters was tempered by a selective naturalism. Dav-
is's paintings evoke the picturesque charm of the *quartiers*
while scrupulously respecting the flatness of the canvas by
emphasizing the decorative and tactile properties of paint.
In such paintings as *Place Pasdeloup* or *Place des Vosges,
Nos. 1* and *2*, he alternated areas of smoothly brushed
paint with dense or stippled passages, employing abrupt
color transitions that make it impossible to read space

three dimensionally. He often indulged his interest in signs and words to enliven the surface, communicating both the general and the particular qualities of the space without ever resorting to direct transcription. In a statement written for the Newark Museum a dozen years after he had painted the Paris canvases, Davis offered an explanation of his new concepts:

> If one went to the Place des Vosges full of enthusiasm for its rich historical background, the fact that Victor Hugo lived there, etc., then the painting made to express that interest would have to be factual in the sense of it being a color and shape replica.... But if one came accidentally into the Place des Vosges, unaware of its history, as I did, then the interest aroused comes purely from the physical aspect of the scene itself.... One paints this sort of interest without regard to historical accuracy, civic pride, or the name of the town or place. My picture looks like the Place des Vosges, but it looks only like certain color-shape relations which are inherently there. These color-shape relations are beautiful, independent of the objects they are associated with, therefore they are abstract—but since they are always associated with some sort of objects, they are concrete and unique in each case.[12]

IT WAS in conjunction with the painting of Paris street scenes that Davis launched his printmaking career, producing eleven lithographs or half of his entire output in that medium in less than a year's time. As a young man he had shown little interest in printmaking in contrast to other followers of Henri. His initial experiments with etching c. 1915-1916 were stimulated by his close friendship with Sloan, one of the genuine masters of that medium. The older artist maintained that he had provided the plate for Davis's *Two Women* as well as the necessary instruction in the etching technique. It must be said that this tentative and seemingly unique impression bespeaks no

particular sensitivity for the linear and tonal qualities associated with etching. Apart from two powerful but technically crude monotypes, which project a Daumier-like sense of shape and a painterly application of the ink, Davis does not seem to have carried his experiments further. In the absence of a vital printmaking tradition comparable to that of Europe, it is unlikely that Davis would have had consistent exposure to the various media. Whereas dominance of etching in America can be traced to the enormous prestige the works of James McNeill Whistler enjoyed in the early twentieth century, there was really no comparable enthusiasm for lithography until the 1930s when the workshop facilities made available by the government-sponsored Federal Art Project stimulated a genuine artistic revival of the medium.

The drawings of Paris scenes in the Amon Carter Museum's collection of Davis's work seem to have served as the point of departure for both paintings and prints. It is virtually certain that the prints were drawn on stone, as the character of the crayon line closely resembles direct drawing. If one compares the lithograph *Adit*, the paintings *Industry* and *Adit No. 2*, and the gouache *Street in Paris* with the sketchbook drawing, it is evident that the latter contained the essential physical "facts" that prompted the painter to undertake a series of variations of which the lithograph may have represented a final black and white synthesis. Some of the prints are more technically ambitious than others: the lithograph *Hotel Café* most closely conforms to the quickly sketched drawing, although the line has a harder, more insistent quality. Similarly, the lithograph *Au Bon Coin* intensifies the geometric character implicit in the architectural forms of the drawing while introducing limited areas of matte black ink that are strikingly set off against the white of the paper to produce a collage-like effect.

The magnificent seventeenth-century Place des Vosges in the historic *Marais* inspired two drawings, two paintings, and a lithograph. The drawing for *Place des Vosges* in the Amon Carter Museum contains color notations that are largely carried out in the paintings. In the print, Davis in-

12 Statement written by Stuart Davis for the Newark Museum, September 12, 1940.

tensified the abrupt spatial transitions of the building facades by introducing unusually strong blacks that stengthened the abstract, two-dimensional character of the shapes in relation to the subordinate white areas. He also added a typically masculine touch of humor by drawing his initials on the floor of the *pissoir* at the right.

If Davis's Paris paintings appear less intensely analytical or constructivist in intention than the eggbeater series, they reveal a renewed interest in the sensuous properties of paint that had not been characteristic of his paintings for a decade. As Picasso and Braque had done, Davis mixed sand with his pigments to enrich the tactility of his surface and to enliven the sense of pattern that marks these canvases. In some of his lithographs, Davis made a special effort to find graphic equivalents for the textural concerns that marked the oils *Rue des Rats* Nos. 1 and 2, and the gouache *Rue Descartes*. In the lithograph *Rue des Rats*, he used crayon to convey the light-stippled areas of the roof and introduced dense, woven patterns in the sky and street, which create an effect comparable to the crusty, sand-permeated pigment. In the painting *Arch Hotel*, Davis pointedly contrasted the "real" granulation of the arches' facade that resulted from the admixture of sand with the simulated granulation produced by his brush. In the lithographs *Arch* Nos. 1 and 2, he employed thick, rich inks, a density of line, and a variety of tones as he sought to create similar surface activity.

The sketchbook drawing of *Place Pasdeloup* sheds light on the construction of the painting with its flag-like bands of bright color and animated lines. Though Davis changed his mind about some of the colors, his canvas adheres closely to the jaunty promise of the drawing. The two lithographs that followed pursue inherently different objectives: the first explores a limited tonal range and continues the essentially calligraphic spirit of the drawing, whereas the second is more reductive, eliminating many of the linear flourishes to emphasize, in heightened contrast of black and white, the collage-like properties of the painting.

Since the Paris lithographs recapitulate the composi-

tions of the paintings, it would seem that Davis saw lithography as an alternative way of exploring specific formal problems rather than as an independent means of expression. Nonetheless, these prints demonstrate an uncommon sensitivity to the compositional function of paper that is the mark of a sophisticated understanding of the aesthetic and formal properties of the medium.

On his return to New York in August 1929, Davis experienced a severe culture shock; he later said he was "appalled and depressed by its giantism," but he also acknowledged his need for the city's "impersonal dynamics."[13] Although his direct exposure to Parisian avantgarde art had no lasting effect on his painting and theorizing, it certainly reinforced his conviction that modernism and the American experience were entirely compatible. Indeed, from the 1930s on, Davis was the only painter of major importance to embrace American subject matter while still retaining the formalist goals of cubism.

Not surprisingly, a group of canvases titled *New York–Paris* proclaimed the physical and aesthetic disorientation that Davis experienced over the next two years. Returning to the concept he had experimented with a dozen years earlier in *Multiple Views*, Davis created paintings that now exploited differences of scale and style—human and oversize, classical and modern, abstract and representational—combining familiar elements of his recent Paris views with images of New York that were often "quotations" of much earlier sketches. In *New York–Paris*, Nos. 2 and 3 (1931), Davis alternated fragments from *Hotel de France, Place des Vosges*, and *Hotel Café* with older and more recent New York and Gloucester motifs to create a "reconstituted" reality. Unlike the highly faceted, consciously constructed space of the Paris paintings, the space of these canvases is nonspecific, associational, and as freeflowing as a conversation that intermingles reminiscences of the past with details of the present.

It was also in 1931 that Davis made his most important contribution to American printmaking, producing five

[13] *Stuart Davis*, unpaginated.

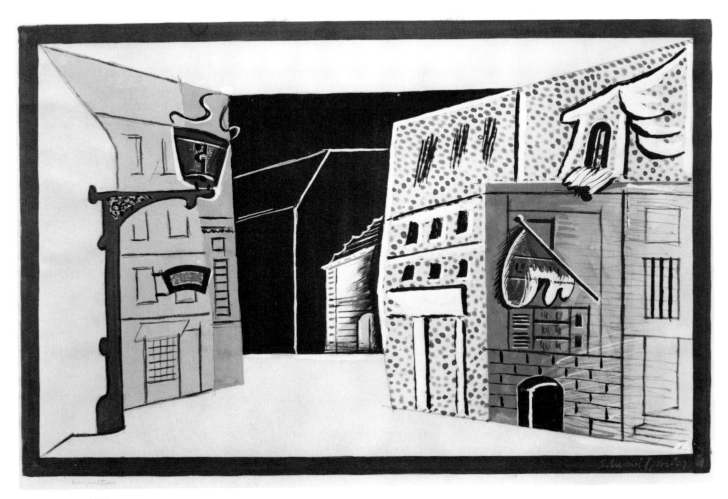

Rue Descartes, 1929
Gouache, black ink, and graphite on paper, 12¾ x 18⅝ in., Hirschl & Adler Galleries, New York

densely packed, highly original black and white lithographs that, like his paintings, reflect his goal of uniting diverse aspects of time and place in a new and distinctly two-dimensional reality. Although Davis continued to draw on a repertory of early images, the prints—with one exception—are not directly tied to previously established compositions as were the Paris lithographs. Rather, they represent an effort to bring to bear on that relatively conservative medium the same considerations that marked his attempt to link the formalist discipline of cubist painting with the content of the American scene. The uniform sophistication of these prints, the careful balancing of black and white areas, of geometrically and organically abstracted forms, is absolutely unique in a period when lithography was dominated by the graphic language of urban or regional realists. Their exceptionally high technical

9

quality suggests that Davis worked with a skilled and sensitive printer such as the highly respected George C. Miller. A lack of documentation makes it impossible to confirm this identification, but it is known that Miller gave demonstrations at the Whitney Studio Club, which Davis frequented in the 1920s, and that he printed for artists, like Davis, associated with the Downtown Gallery.

The format of all but one of the lithographs is horizontal, and four of the subjects can be characterized as city or townscapes. Two of the prints, *Sixth Avenue El* and *Two Figures and El*, feature a distinctive New York City iconography. A preparatory drawing for *Sixth Avenue El* sets out, in reverse, the tripartite configuration of motifs that were drawn primarily from a 1926 sketchbook. These include a Jewish delicatessen sign and streetlight that have been superimposed on a study of drapery, a barbershop pole and gum-vending machine, and street views dominated by the Jefferson Market, whereas the elements of a tailor's shop seem to have been invented freely. Davis also appropriated a large Leger-like head from a contemporaneous painting, *Buildings and Figures*, balancing it neatly against the streetlight so that the eye travels back and forth over the variegated spaces but is securely anchored at either end. A preparatory drawing conveys the linear configuration of the lithograph *Two Figures and El* including the strange, organically abstracted figures that document Davis's continuing receptivity to Picasso's cubism as well as a new sensitivity to the biomorphism of Miró and the surrealists. Compared with *Sixth Avenue El*, direct quotations from nature are less evident; there is more concern with movement, and the space is more like a collage. Although spatial or figure-ground relationships are less ambiguous in *Theatre on the Beach*, the content of the lithograph is certainly enigmatic. The elegant theater harkens back to Davis's stay in Paris, and the inscription *L'Atelier* on one of the related drawings points to a location far from the rocky Massachusetts coast depicted at the left. In the magnificent *Barber Shop Chord*, Davis once again set off a highly abstracted but essentially organic fig-

ure against geometrically simplified architectural elements that he adapted from the gouache *New England Street* (c. 1929). Although the gouache contained passages of cubist patterning similar to those Davis had employed in his Paris views, its composition was stable and spatially coherent. In the print, Davis reversed the architectural and landscape components, compressed space, and altered scale so that the similarity of the works is not immediately apparent. Moreover, the stark contrast of luminous white paper and rich black ink invests the forms with a lunar severity that is markedly different from the tranquil harbor view.

In the four prints discussed, Davis contrasted the newly constituted realities of the American city or seacoast with the organic discontinuity of the figure. Only in *Composition* did he remove the figure completely from a spatial context, placing a vague anatomical unit and a dislocated, floating arm against a unifying black ground. If this print lacks the monumentality and complexity that distinguish the other 1931 lithographs, its emphasis on flat patterns and its virtual abstraction prefigure many of Davis's later painterly concerns.

Although the 1930s were productive years for Davis, they were marked by economic and social turbulence that generated his most sustained political activity. By 1933, a quarter of the American labor force was unemployed, and the economic crisis was especially devastating among artists. When the U.S. government attempted to fill the gap by organizing various relief projects to employ artists in the creation of public works, Davis was among the first to enroll. He joined the first federally supported art program, the Public Works of Art Project, in December 1933 and remained on its roster throughout its seven-month existence. Thereafter, he was inscribed in New York City's Emergency Relief Bureau, which was absorbed by the Works Progress Administration's Federal Art Project (FAP) in August 1935. He remained active in the FAP until 1939. The far-reaching activities of the project—whose membership comprised visual artists, musicians, actors,

and writers—profoundly affected the cultural life of this nation. The art project alone sponsored literally thousands of murals, easel paintings, sculpture, graphics, photographs, and an Index of American Design; it also provided professional services and a vast program of art education.

While Davis's enrollment in the FAP helped to alleviate his desperate poverty and provided him with essential art materials, he was also motivated to join because he felt that the project offered artists an unparalleled opportunity to speak to a larger audience and thus challenge the dictatorship of taste in art by a "small economically enfranchised class"[14] of society. Davis's conviction that vanguard artists had a specific place in any movement for social progress was tied to his positive evaluation of the didactic character of modernism. John Lane has shown that Davis's ideas regarding the social responsibilities of artists were initially shaped by his contacts with Henri and Sloan and subsequently affected by both philosophic pragmatism and Marxist aesthetics. The latter was especially popular during the militant Depression years, and although Davis was impressed by many aspects of Marxist theory, he vehemently rejected its insistence that the value of a work of art was determined by the relevance of its content. Indeed, his private and public writings in the 1930s address both popular skepticism about the place of abstract art in American life and the Marxist charges that abstract art had no social content.

At about the same time he enrolled in the FAP, Davis became a member and was elected President of the Artists Union. He was also editor of its outspoken publication, Art Front (1935-1936), and used its pages to wickedly satirize the American regionalists and their isolationist supporters as well as the self-serving government bureaucrats who criticized the artists in the FAP for having inflated ideas of their importance. As a founder of the American Artists Congress of which he was National Executive Secretary (1936-1938) and National Chairman (1938-1940), Davis argued that the Depression had made artists conscious of their rights as American workers and that the efforts of the Union had "... gone a long way toward showing that the best American art cannot be developed by merely encouraging a handpicked few. Their insistence on a democratic extension of government support to young and unknown artists has brought a vast variety of talent completely ignored by private patronage and commercial galleries."[15]

Throughout the 1930s Davis was America's foremost practitioner of abstract art and its indefatigable polemicist. His able introduction to the Whitney Museum's major exhibition Abstract Painting in America (1935), in which he defined his concept of painting "as a reality which is parallel to nature" and in which he repeatedly stressed its material identity and its logical procedures, is one of the classic texts of American modernism. At the same time, Davis discovered that abstract art could be just as troublesome to Marxist intellectuals as it was to the cultural know-nothings who opposed anything that was redolent of European culture. In the May 1935 issue of Art Front Davis answered a Marxist critic's charges that excessive preoccupation with formal problems had distanced the abstract artist from the problems of life around him by arguing:

> If the historical process is forcing the artist to relinquish his individualistic isolation and come into the arena of life problems, it may be the abstract artist who is best equipped to give vital expression to such problems—because he has already learned to abandon the ivory tower in his objective approach to his materials.[16]

In an unpublished essay commissioned by Art for the Millions in 1940, Davis decried the general conservatism

[14] Stuart Davis, "From Our Friends," Art Front 1, no. 1 (November 1934): 2.

[15] Stuart Davis, "Why an Artists' Congress?" First American Artists' Congress, New York, 1936, pp. 3-6.

[16] Stuart Davis, "A Medium of Two Dimensions," Art Front 1, no. 5 (May 1935): 6.

of American painting as it was revealed in a large comprehensive exhibition at the World's Fair in 1939. He insisted that:

The quality called "art" has always been abstract and has had its material existence in a series of unique and real orders in the materials of art. Therefore when as today a popular sentiment is organized and promoted which sets up the arts of illustration and domestic naturalism as the inheritors of the social role of art, then an enormous perversion of values takes place which lowers the cultural level and destroys the sources of art production.... The best work of the last seventy-five years is great because it is real contemporary art, which expresses in the materials of art the new lights, speeds and spaces of our epoch. Modern chemistry, physics, electricity, petroleum, radio, have produced a world in which all the conceptions of Time and Space have been enormously expanded and modern and abstract art both reflect and are an active agent in this expansion.[17]

Davis's pragmatic faith in the place of abstract art in American life found its most concrete expression between 1938 and 1940, years in which he made a determined effort to unite social content and abstract style in four murals executed for the FAP. Although he invested considerable thought in developing the iconography for the WNYC and World's Fair murals, Davis felt that emphasis on the formal aspects of his work was of paramount importance, since "The subject matter which is common to all works of art is constructive order and the achievement of it in the material of expression."[18] Rejecting the storytelling realism practiced by most of the Works Progress Administration (WPA) muralists, Davis aimed at raising the aesthetic consciousness of his public through prolonged contemplation of this new "constructive order."

In 1939, under the aegis of the FAP, Davis turned again to lithography, producing three prints for its Graphics Division. As a result of the activities of this division, printmaking gained a new artistic lease on life. The Graphics Division actively fostered the growth of lithography, woodcut, and silkscreen. Artists submitted sketches beforehand, and after approval the printing was done in workshops where advisors provided the requisite technical assistance. Some 200,000 prints were produced from 11,000 designs. The majority were distributed to museums, libraries, and educational institutions.[19] Study of the prints published by the Graphics Division reveals that the overwhelming majority were realist or expressionist in style and that much of the content understandably reflected the social and economic conditions of the day. Davis may have decided to produce prints at this particular time because they offered an opportunity to expand the popular audience for abstract art, in keeping with his contemporaneous campaign to make it part of American cultural life. The artist and print historian Jacob Kainen has shed some light, however, on a second, more practical reason for Davis's renewed printmaking activities.[20] According to Kainen, Davis discouraged him from enrolling in the Easel Project because artists were required to allocate their work to public collections and worked under time constraints, whereas in the Graphics Division they could work at night, learn new techniques, and retain proofs of their prints.

Apart from the isolated 1935 lithograph *Anchor*, which characteristically had its compositional inception in a sketchbook drawing c. 1931-1932, Davis had not devoted himself to the medium in eight years. In the WPA prints,

[17] Stuart Davis, "Abstract Painting Today," unpublished article commissioned in 1940 by *Art for the Millions*. Printed in Kelder, pp. 117, 120.

[18] Stuart Davis, Working Notes for Mural for Studio B, WNYC, March 23, 1939, in Kelder, p. 93.

[19] Jacob Kainen, "The Graphic Arts Division of the WPA Federal Art Project," in Francis V. O'Connor, ed., *New Deal Art Projects, An Anthology of Memoirs* (Washington, D.C.: Smithsonian Institution Press, 1972), p. 157.

[20] Interview with Jacob Kainen, January 1986.

he once again made use of his writings and accompanying drawings. The basis for the lithograph *New Jersey Landscape*, also called *Seine Cart*, is a drawing from a Gloucester sketchbook of 1931-1932, which also served as the compositional source for the 1932 painting *Red Cart*. The character of the lithographed line in the reversed composition is bolder and more abstract. In view of the prominence Davis accorded drawing in his art theory at this time, it is likely that the avoidance of tone or texture in the lithograph was conscious as he sought to demonstrate the constructive power of line. It is quite conceivable that a large pencil drawing of the same configuration was undertaken at this time, not as a preparation for the print but as another independent though simplified variation.

Drawings from the same 1932 Gloucester sketchbook were the inspiration for the lithographs *Harbor Landscape* and *Shapes of Landscape Space*. In the former, apart from enlarging the scale and reversing the composition, Davis dramatically thickened the lines and introduced heavy areas of black ink that all but obliterated the original forms. From entries in his 1939 calendar, we know that he made a gouache of his lithograph design in June 1939. Comparison of the lithograph with *Colors of Spring in the Harbor* suggests that it is the gouache that followed the lithograph. Subsequently, the sketch served Davis in the tempera *Composition* (1946, Seattle Art Museum) and as the matrix of the powerfully simplified color planes of the painting *Midi* (1954). At the time Davis made the drawings that inspired the WPA lithographs, he was immersed in a search for a type of pictorial construction based on a clear and logical relation of formal elements. In his writings he spoke increasingly of the need to subordinate natural appearance to "optical geometry." It is in this light that we should understand the configuration dated September 13, 1932, which generated not only the color lithograph *Shapes of Landscape Space* but at least five other works in different media. The sketchbook drawing is accompanied by this passage:

Directional analogy to natural subject of wharf and boats. The result of proportional space expansion and contraction visualization in simple shape terms disregarding more detail incident than is the habit with the idea of getting a simultaneous view instead of a sequential one.

Davis first applied the configuration to a black and white painting titled *Landscape* (1932, 1935) that stresses the constructive character of line. In the painting *Shapes of Landscape Space* and the eponymous gouache, Davis modified the linear elements of the geometric skeleton and filled in planes of color. In the lithograph, he reduced the number of colors and replaced the earth tones of the painting with pastels that lent the image an airy, lyrical quality. Fifteen years later, at a time when Davis was striving for greater simplification of form in his painting, he once again recycled this fertile configuration: in *Tournos* he obliterated all vestiges of the original nautical motif and introduced wedges of vibrantly interacting color that take on an independent plastic life. The final metamorphosis of the drawing occurred in *Memo* (1956). Here Davis bifurcated the composition to oppose the linear persona to even more simplified solid planes of color. He pointedly introduced references to his art theory: x, his shorthand for "external relations," which included perspective, color, size, and position of shapes; ∞ the symbol for infinity; and the word "any," which alluded to his belief that any subject matter was appropriate because it was rendered neutral by art.[21]

The evolution of this impressive group of works in various media from a single sketchbook drawing affirms the importance of Davis's methodology—the cornerstone of his painting—to his stylistic development. Moreover, it reveals that Davis harbored no hierarchical bias against drawing or printmaking. Rather, he recognized that each medium potentially offered a unique solution to a formal problem.

[21] Lane, p. 71.

The early 1940s were years of continued economic hardship for Davis. His tenure on the FAP had come to an end in 1939; he had been without a gallery for four years; and the small income he earned from teaching art at the New School for Social Research was barely enough to keep him going. Plans for a book on abstract painting and for a set of color lithographs of New York subjects with "an accompanying essay on the ideas and methods involved"[22] were abandoned when Davis was unable to find sponsors. It was doubtless in an effort to generate income that Davis agreed in July 1941 to allow the art publisher Jack Rich to produce a seven-color silkscreen of his 1939 painting *Bass Rocks*.

As he had done in connection with the lithograph *Shapes of Landscape Space*, Davis modified the intensity of the original palette. In a statement prepared by the artist for the publisher, which was clearly intended to enlighten the prospective purchaser of the abstract silkscreen, Davis once again underscored the didactic character of such works:

> Pictures of this kind ... help to keep the eye of the beholder alive, force him to make observations, and give value to aspects of nature which everyday preoccupations too often leave unnoticed. Everybody has potentialities of art appreciation, but most have little opportunity to develop them. This is one reason the artist plays an important social role in his specialized profession, which is sometimes overlooked. He keeps alive one of the most important faculties of man by cultivating it, and, by his work, continues to give objective proof ... of the possibility of enjoyment of the form and color of our environment.[23]

In 1941 Davis also resumed his affiliation with the Downtown Gallery where he had shown his work from 1927 to 1936. His solo exhibition in 1943 generated the interest of collectors and curators and resulted in a number of museum shows in 1945, including the artist's first retrospective at the Museum of Modern Art. If Davis's paintings of the 1940s were characterized by increasing elimination of the selective naturalism he had retained in the previous decade, his work nonetheless retained a philosophic and emotional connection with the natural world. In contrast to his practice in the 1930s, Davis accorded color a more assertive role in his paintings, and, under the influence of Gestalt theory, he began to avoid composing with a center focus in favor of a pictorial construction that aimed at total or whole focus.[24]

John Lane has seen parallels between Davis's efforts to forge a postcubist style in the mid 1940s and those of certain abstract expressionists, arguing that in such canvases as *Ultramarine* (1943, Pennsylvania Academy of the Fine Arts) the enriched surface "overpowered the regularity of Davis's underlying structure and made his own work seem to him to be liberated from Cubism."[25] Yet Lane recognized that Davis's attitude toward the scale of his canvases, his careful preparation of them, and his handling of paint never really broke with the cubism tradition. Unlike Pollock who bypassed the structural strategies of cubism or De Kooning who challenged them, Davis persisted in his effort to accommodate them to a constantly changing American experience.

Davis's commitment to an essentially materialistic and objective approach to painting was antithetical to the spontaneity and subjectivism that were associated with abstract expressionism. In the 1950s, the decade of its greatest influence, he increasingly withdrew from the New York art scene to engage in a critical introspection that would involve periodic reassessment of his ideas and achievements of the previous twenty-five years. It was during this period of retrospective consolidation that Davis painted a number of the works that have been dis-

[22] Letter dated July 14, 1941, in the artist's file at the Whitney Museum of American Art.
[23] Stuart Davis, Statement for *Contemporary American Painters Series*, Jack C. Rich, Publisher, New York, 1942.

[24] Lane, p. 59.
[25] Ibid., pp. 65, 67.

Colonial Cubism, 1954
Oil on canvas, 45¼ × 60⅜ in., Collection, Walker Art Center, Minneapolis; Gift of the T. B. Walker Foundation

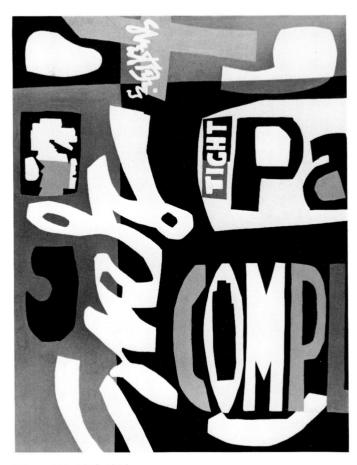

Blips and Ifs, 1963-1964
Oil on canvas, 71⅛ × 53⅛ in., Amon Carter Museum, Acquisition in memory of John de Menil, Trustee, Amon Carter Museum, 1961-1969

cussed in relation to the prints he produced for the Federal Art Project.

By the mid 1950s a new monumentality and a greater simplicity characterized his work. Davis reaffirmed its cubist heritage and his own particular mission in such uniquely American paintings as *Colonial Cubism*, which recast, in bolder colors and clarified geometric shapes, the formal relationships first examined in a 1922 painting.[26] More and more in the last decade of his life Davis looked nostalgically to the past as the stimulus for new formal strategies.

Davis's initial fascination with signs and symbols drawn from the external phenomenological world developed into a virtual obsession with those drawn from the internal world of art theory. His last prints—the color lithograph *Detail Study for "Cliché"* (1957) and the silkscreens *Study for a Drawing* (1955) and *Composition* (1964)—abound in the symbolic language of his private art discourse. Words as abstract color/shapes dominate *Blips and Ifs* (1963-

[26] *Abstraction* (1922, oil on canvas), illus. in Lane, p. 76.

1964), one of his largest canvases and among his last completed works before his death in June 1964. This painting, like other works of the 1960s, has the impact of a vast detail of some even more monumental composition. It is marked by a degree of surface tension that is notably absent from the majority of Davis's late paintings.

At the time of Davis's death, when the achievements of abstract expressionism were temporarily overshadowed by the emergence of an aggressively American and subject-oriented pop style, it was not uncommon for writers to speak of similarities between his earlier work and this updated version of American scene painting. Davis was justifiably appalled by the association, for it failed to recognize that his lifelong struggle to join the classic syntax of cubism with vernacular realism was an outgrowth of his profound understanding of the ideational character of painting and of his desire to reaffirm the universal validity and vitality of the modernist tradition.

DIANE KELDER

16

STUART DAVIS: A CATALOGUE RAISONNÉ OF THE PRINTS

THE CATALOGUE RAISONNÉ is based on Sylvan Cole's checklist, *The Prints of Stuart Davis* (New York: Associated American Artists, 1976), with additional information compiled by Sylvan Cole and Jane Myers.

Several of the dates for the prints have been changed since the 1976 checklist was published. In 1943, the Whitney Museum of American Art asked Davis to date several of the works in their permanent collection. Among them was the lithograph *Hotel de France* to which Davis assigned a date of 1929 (curatorial files, Whitney Museum of American Art). *Two Heads* appeared in the Downtown Gallery's "American Print Makers Third Annual Exhibition" in December 1929, indicating a date of 1929, rather than 1930, for this lithograph.

The Downtown Gallery date stamps on the verso indicate when the print was received by the gallery.

Included in each entry are abbreviations for the institutions holding impressions of that print. The prints illustrated are in the collection of the Amon Carter Museum.

Seventh Avenue, c. 1915
Monotype on paper, 9¹³⁄₁₆ x 7¹⁵⁄₁₆ in., Delaware Art Museum; Gift of
Helen Farr Sloan

The Argument, c. 1915
Monotype on paper, 7¹⁄₁₆ x 5³⁄₁₆ in., Delaware Art Museum; Gift of
Helen Farr Sloan

18

ABBREVIATIONS

AGAA — Addison Gallery of American Art
Andover, Massachusetts

AIC — The Art Institute of Chicago
Chicago, Illinois

BALL — Ball State University Art Gallery
Muncie, Indiana

BALT — The Baltimore Museum of Art
Baltimore, Maryland

BIAA — The Butler Institute of American Art
Youngstown, Ohio

BRIT — The British Museum
London, England

BROOK — The Brooklyn Museum
Brooklyn, New York

CI — Museum of Art, Carnegie Institute
Pittsburgh, Pennsylvania

CIN — Cincinnati Art Museum
Cincinnati, Ohio

CLEVE — The Cleveland Museum of Art
Cleveland, Ohio

CORNELL — Herbert F. Johnson Museum of Art, Cornell University
Ithaca, New York

CWMFA — Charles A. Wustum Museum of Fine Arts
Racine, Wisconsin

DAM — Delaware Art Museum
Wilmington, Delaware

DIA — Detroit Institute of Arts
Detroit, Michigan

FOGG — Harvard University Art Museums, Fogg Art Museum
Cambridge, Massachusetts

GMA — Georgia Museum of Art, The University of Georgia
Athens, Georgia

HIGH — The High Museum of Art
Atlanta, Georgia

HMSG — Hirshhorn Museum and Sculpture Garden, Smithsonian
Institution, Washington, D.C.

IMA — Indianapolis Museum of Art
Indianapolis, Indiana

IOWA — Museum of Art, University of Iowa
Iowa City, Iowa

IUAM — Indiana University Art Museum
Bloomington, Indiana

LC — The Library of Congress
Washington, D.C.

MCNAY — Marion Koogler McNay Art Museum
San Antonio, Texas

MEMR — Memorial Art Gallery of the University of Rochester
Rochester, New York

MET — Metropolitan Museum of Art
New York, New York

MFAB — Museum of Fine Arts, Boston
Boston, Massachusetts

MOMA — The Museum of Modern Art
New York, New York

NEWARK — Newark Museum
Newark, New Jersey

NMAA — National Museum of American Art, Smithsonian
Institution, Washington, D.C.

NORTON — Norton Gallery of Art
West Palm Beach, Florida

NYPL — The New York Public Library
New York, New York

OAC — Oklahoma Art Center
Oklahoma City, Oklahoma

PAFA — Pennsylvania Academy of the Fine Arts
Philadelphia, Pennsylvania

PAM — Portland Art Museum
Portland, Oregon

PC — The Phillips Collection
Washington, D.C.

PMA — Philadelphia Museum of Art
Philadelphia, Pennsylvania

PSU — The Pennsylvania State University, Museum of Art
University Park, Pennsylvania

PU — The Art Museum, Princeton University
Princeton, New Jersey

RISD — Rhode Island School of Design
Providence, Rhode Island

SHELDON — Sheldon Memorial Art Gallery
Lincoln, Nebraska

| | | | | |
|---|---|---|---|
| SMITH | Smith College Museum of Art
Northampton, Massachusetts | UWM | Wisconsin Union, University of Wisconsin-Madison
Madison, Wisconsin |
| UD | University Gallery, University of Delaware
Newark, Delaware | WALKER | Walker Art Center
Minneapolis, Minnesota |
| UKAM | University of Kentucky Art Museum
Lexington, Kentucky | WMAA | Whitney Museum of American Art
New York, New York |
| UMMA | The University of Michigan Museum of Art
Ann Arbor, Michigan | YALE | Yale University Art Gallery
New Haven, Connecticut |
| UNM | University Art Museum, The University of New Mexico
Albuquerque, New Mexico | | |

CATALOGUE RAISONNÉ

PRINTS: 1915-1929

STUART DAVIS'S fascination with, and adoption of, the modernist aesthetic prompted his sole trip abroad in 1928-1929. In Paris, Davis and other American colleagues participated in the intellectual and cultural milieu that had nourished those French artists who had led Davis to new artistic ground following the Armory Show of 1913. Among the Americans in Paris were a growing number of artists eager to pursue lithography—at that time still largely associated with commercial reproduction—as a distinct art form. In these surroundings, Davis embarked upon his most concerted printmaking effort, producing eleven lithographs before returning to America in the summer of 1929.

Davis's earlier, somewhat perfunctory, prints of about 1915—an etching and two monotypes—were created under the supervision of his friend, the accomplished printmaker, John Sloan.[1] These prints bear a stylistic relation to illustrations Davis produced for The Masses during his three-year association from 1913 to 1916 with the politically satirical magazine.[2] The prints, whose narrative content also parallels Davis's contemporary work in other mediums, depict confrontations between pairs of individuals, rendered loosely in amorphous silhouettes. No doubt Davis's affiliation with The Masses crowd, among them Sloan, instilled in the young artist at least a rudimen-

tary knowledge of such printmaking fundamentals as drawing with a lithographic crayon, an understanding of the technology of mechanical reproduction, and an appreciation of the concept of cooperative endeavors between artist and printer.

As he shed the figurative, naturalistic mode of his Ashcan School period, Davis's work reflects his absorption of abstract principles and the desire to explore the reordering of spatial relationships. While experimenting with cubism he also adhered to the counsel of his mentor, Robert Henri, to paint contemporary life. As he had roamed the streets of New York in search of appropriate subject matter, so Davis filled his 1928-1929 sketchbooks with vignettes of the French capital's emotional core—its streets, hotels, and cafés, devoid of the human figure, yet pulsating with a rhythmic spirit inherently Parisian. The bohemian routine to which Davis subscribed was noted in the Paris edition of the New York Herald on April 27, 1929:

Now that the weather is sufficiently warm for outdoor sketching, Stuart Davis may be seen each morning in a large cafe of which the pillars are decorated with bad paintings and which has a water fountain in the centre and a soda fountain in one corner. Shortly after noon, however, he starts out with his pad and pencil

and although he has sent nearly three boatloads of canvases to New York since his arrival here last fall, he is planning to send six boatloads this summer.[3]

In his Paris lithographs, Davis exhibits little fascination for historic or architectural subjects redolent of the city's distinguished past but selects, instead, uncelebrated corners of the Latin Quarter and the Montparnasse district. He focused on views drawn from the 5th, 6th, and 14th arrondissements; in the latter he rented a studio (now destroyed) from fellow American artist Jan Matulka at 50 rue Vercingétorix. Diane Kelder has outlined the primary role of the Paris prints in the artist's recycling of imagery—each of the eleven prints has at least one, often two, related paintings or gouaches that recapitulate the prints' themes.

Davis was emphatic that his compositions should evoke a sense of place rather than serve as literal transcriptions, and his Paris prints vary in the degree to which they adhere to the realism of their individual sources. Eschewing an overemphasis on subject matter, Davis retained only selective details as both formal enhancement and as suggestion of place in the Place Pasdeloup drawing. This sketch, rendered on the site, accurately records the actual location of buildings in the Place Pasdeloup,[4] located in the 11th arrondissement. In the lithographs, while the relation of the architectural elements remains intact, the central structure is reduced to its linear essentials. The delicately balanced composition is animated by the details that caught Davis's selective eye: the serpentine swirls of the balconies' ornamental ironwork, the urns in the far courtyard, the lamppost, and the rooster atop La Cressonee restaurant.

Other sites in Davis's lithographs are more generalized, although they appear to be faithful translations of Parisian streetcorners. Hotel Café, Hotel de France, and Au Bon Coin—a title that possibly refers to the name of the café depicted in the lithograph—again express universal aspects of the city and are difficult to locate among the myriad number of such scenes in Paris. The precise geographical source for prints of the 1928-1929 period is complicated by Davis's uneven French. A rue des Rats, for example, does not appear in Paris gazetteers, although a plausible candidate for this narrow street is the rue Rataud in the 5th arrondissement, an area the artist frequented. The source for the title of the print Adit remains a mystery and its location is unidentified.[5] Attesting to Davis's disregard for specifying his subjects is the fact that the inscription appearing on the building in each version of the scene, all representing a virtually identical site, varies from "Rue des Ra . . ." in the gouache to "RUE VANDA[MME]" in the drawing, to what appears to read "Rue Vercingétorix" in one of the two paintings based on the sketch.

In some of the Paris lithographs such as Rue de l'Echaudé, where the street scene has been compressed into a series of stage-like structures, the artist removed the composition one step further from reality by distorting and realigning the original site. Likewise in Place des Vosges, this popular square, designed in the seventeenth century in a classically symmetrical plan, has been transformed. The artist condensed the elegant facades from a row of five pavillons into three as they recede in an undulating procession, converging on the Hôtel de Rohan-Guéménée, where Victor Hugo once maintained an apartment.

Davis's exploration of spatial concepts becomes more complex in the lithographs Arch No. 1 and Arch No. 2, where the predominant motif originated in drawings of the Porte St. Martin, located, like the Place Pasdeloup, near the Place de la Republique. Taking his inspiration from a series of sketchbook renderings, Davis issued two prints and three paintings, all featuring a single opening in the tripartite portal, built in 1674 to commemorate Louis XIV's victory over the Dutch, Germans, and Spanish. One drawing, with the city hall tower visible through the archway (fig. 6b), closely resembles the scene as it appears today. In his two lithographs, Davis refines and reassembles these on-site impressions, creating ambitious compositional arrangements while retaining the overriding presence of the arch, combining it with Parisian facades and an oversized rum bottle. The "split composition" of

these prints, featuring buildings adjacent to the archway, provides the artist with an opportunity to juxtapose interior and exterior space in a single image, a contrast that intrigued him.[6]

Although Davis's Paris prints do not lend themselves to a strict chronology, it may be that such lithographs as *Arch No. 1* and *Arch No. 2*, characterized by more complex imagery, fall later in the series than the more direct interpretations of Parisian street scenes. Technically the artist's development is apparent when comparing a 1928 print such as *Adit* with other lithographs in the series. In the earlier print, Davis, the consummate draftsman, employs calligraphic methods including crosshatching and incised lines, as well as local shading and modulation of tone. In other Paris prints, the artist favored more generalized forms, broader planes, and pronounced contrasts of black and white to evoke the structural rigidity and spatial ambiguity of his architectonic subjects.

Certain technical details regarding Davis's printmaking habits in Paris remain incomplete. Most of these lithographs were issued in small editions of ten, twenty, or thirty. Many of the Americans making prints in Paris in the 1920s sought the expertise of Edmond Desjobert, a printer noted for his technical skill and for the rich contrasts he achieved through his choice of inks.[7] Such master printmakers as Louis Lozowick, Yasuo Kuniyoshi, Benton Spruance, Howard Cook, and Adolf Dehn had their lithographs printed at the Atelier Desjobert. Although it has not been established with certainty that Davis worked with Desjobert, it is likely that this was the case. The Paris lithographs in the Amon Carter Museum collection are executed in the *chine collé* technique (whereby the sheet on which the image is printed is affixed to another, heavier, sheet during the printing process) and the paper used is consistent with that found in other prints from the Desjobert studio.[8] In that facility, Davis would have come into contact with some of the most talented American printmakers of the period.

Davis executed one other print in 1929, probably shortly after his return from abroad. *Two Heads* printed in an edition of twelve, recalls the pairing of conversational figures in Davis's illustrations for *The Masses*. In 1929 the print was exhibited with a group of Davis's Paris lithographs at Edith Halpert's Downtown Gallery in the third annual American Print Makers exhibition. Davis's *Hotel de France* was admired for its "blond beauty of pale planes, curling arabesques, a sweep of line leading out with invitation to the unseen."[9]

Halpert, a dealer with whom Davis enjoyed a long association, handled all of Davis's Paris work through her gallery and exhibited his Paris paintings in the late 1920s and early 1930s.[10] Davis's prints were first represented at the Downtown Gallery as early as a few months after his arrival in Paris when, in October 1928, three of his paintings and a single print were shown in the Gallery's "Exhibition of Works by Americans in Paris."

Critical acknowledgment was also accorded Davis's Paris lithograph *Rue des Rats*, when it was selected by John Sloan for inclusion in the American Institute of Graphic Arts' fifth annual "Fifty Prints of the Year" exhibition. Considered an important indicator of modern printmaking, this exhibition, like the American Print Makers annuals, traveled to cities around the country, creating a national audience for contemporary prints.

J.M.

1. At this time, both Sloan and Davis were working for the radical magazine *The Masses*, and in the summer of 1915, Davis joined Sloan in Gloucester. John Sloan's widow suggests (letter to Jane Myers, August 1, 1985) that the etching was probably made in New York, since there was no etching press in Gloucester. The fact that the three prints, as well as the etching plate, remained with Sloan, indicates Davis's indifferent attitude toward his first experiments in printmaking.

2. See Rebecca Zurier, *Art for the Masses (1911-1917): A Radical Magazine and its Graphics* (New Haven, CT: Yale University Art Gallery, 1985).

3. "Scrapbooks," Stuart Davis papers. Archives of American Art, Smithsonian Institution, Washington, D.C., reel N584, frame 225.

4. Named for composer and conductor De Jules-Etienne Pasdeloup (1819-1887).

5. "Adit" has no French translation. The Latin words "aditio" and "ad-

itus," however, refer to an "approach," suggesting the entrance Davis is depicting.

6. For example, *House and Street*, 1931, Whitney Museum of American Art.

7. Clinton Adams, *American Lithographers 1900-1960: The Artists and Their Printers* (Albuquerque: The University of New Mexico Press, 1983), pp. 73-76.

8. I am grateful to Janet Flint for sharing this information with me. Stanley William Hayter has also stated that Davis made prints in his Paris studio [Jacob Kainen, "An Interview with Stanley William Hayter," *Arts Magazine* 60 (January 1986): 64-67]. During the period when Davis lived in Paris, Hayter's workshop was located on the rue de Moulin Vert, in the same vicinity where Davis resided. It is highly unlikely that Davis worked with Hayter, however, for Hayter's studio (which he moved in 1933 to 17 rue Campagne-Premier, thereupon establishing his famous Atelier 17) was known for intaglio printing rather than lithography, the print medium in which Davis worked.

9. Elisabeth Luther Cary, "Pre-Holiday Offerings in Art Galleries: Watercolors and Prints," *New York Times*, December 15, 1929, Section 10, p. 12. Davis's Paris prints also appeared in the fourth annual American Print Makers exhibition. Each of these exhibitions included four prints by Davis. In 1929 they were *Arch No. 1, Hotel de France, Hotel Café*, and *Two Heads*; and in 1930, *Place Pasdeloup No. 2, Arch No. 2, Hotel Café*, and *Paris Street* (possibly *Rue des Rats* or *Rue de l'Echaudé*).

10. A large group of Davis's prints from the Downtown Gallery's stock was sold at an auction after Halpert's death, [*Nineteenth and Twentieth Century Prints* (New York: Sotheby Parke Bernet, February 8-9, 1973)].

1. *Two Women*, c. 1915

Etching
$11^{13}/_{16} \times 9^{13}/_{16}$ in. (30 × 25 cm)
Division of Graphic Arts, National Museum
of American History, Smithsonian Institution

Only a single impression appears to have
been made by Stuart Davis of this print. In
the middle 1960s, this impression, as well as
the etching plate, were donated to the
Smithsonian Institution by Helen Farr Sloan,
widow of John Sloan. A second print was
made from the original plate in 1971.

Cole 1

2. *Adit*, 1928

Lithograph on stone
Edition 10
11¾ × 10⅛ in. (29.9 × 25.7 cm)
Inscribed, l.r. on stone: "SD"

Amon Carter Museum impression on chine
collé; inscribed, l.l. in graphite: (below im-
age) "9/10"; l.r. in graphite: (below image)
"Stuart Davis"; verso, l.l. stamp: "OCT 31
1930" [The Downtown Gallery]

Cole 2 CI, LC
One impression is numbered "0/10."

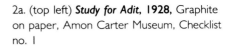

2a. (top left) *Study for Adit*, 1928, Graphite on paper, Amon Carter Museum, Checklist no. 1

2b. (top right) *Street in Paris*, 1928, Gouache on cardboard, 19⅝ x 15⅛ in., Collection of the Newark Museum

2c. (lower left) *Industry*, 1928, Oil on canvas mounted on masonite, 28⅛ x 23 in., University of Arizona Museum of Art, Tucson; Gift of C. Leonard Pfeiffer

2d. (lower right) *Adit No. 2*, 1928, Oil on canvas, 29 x 24 in., The Lane Collection

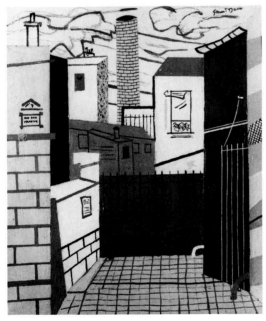

3. *Place des Vosges*, 1928

Lithograph on stone
Edition 10
9¹⁄₁₆ × 13⁷⁄₁₆ in. (23.0 × 34.2 cm)
Inscribed, l.r. on stone: "SD"

Amon Carter Museum impression on chine collé; inscribed, l.l. in graphite: (below image) "6/10", (bottom left corner of sheet in a different hand) "Place des Vosges"; l.r. in graphite: (below image) "Stuart Davis"

Cole 3 AIC, LC, PC, WMAA

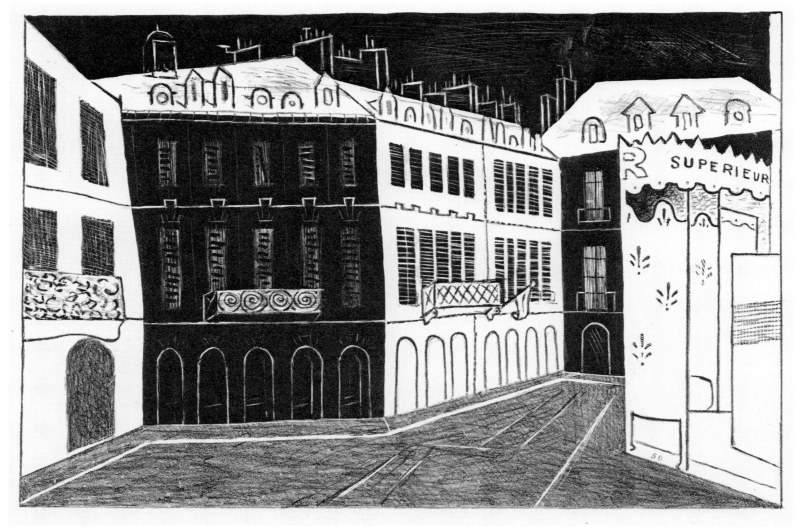

30

3a. (facing) *Place des Vosges;* Photograph courtesy of Mr. and Mrs. J. H. Motes

3b. (top left) *Study for Place des Vosges,* **1928,** Graphite on paper, Amon Carter Museum, Checklist no. 4

3c. (top right) *Study for Place des Vosges,* **1928,** Graphite on paper, 10⅝ × 8½ in., Collection of Earl Davis

3d. (lower left) *Place des Vosges No. 2,* **1928,** Oil on canvas, Herbert F. Johnson Museum of Art, Cornell University; Bequest of Helen Kroll Kramer; Dr. and Mrs. Milton Lurie Kramer Collection, Checklist no. 20

3e. (lower right) *Place des Vosges No. 1,* **1928,** Oil on canvas, 21 × 28¾ in., Collection of the Newark Museum

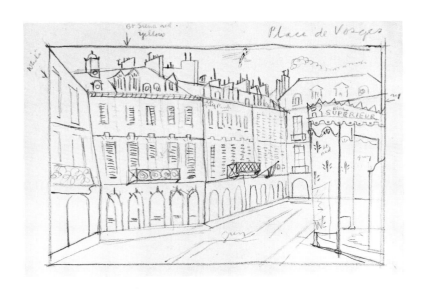

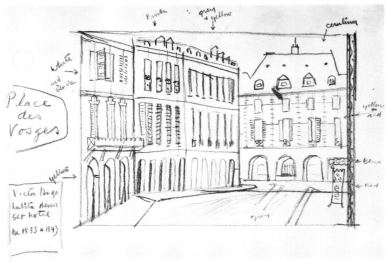

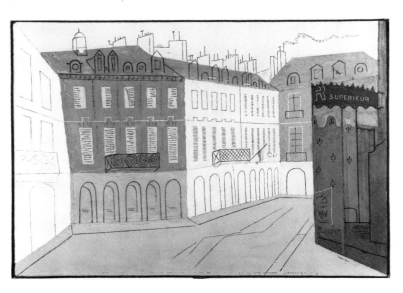

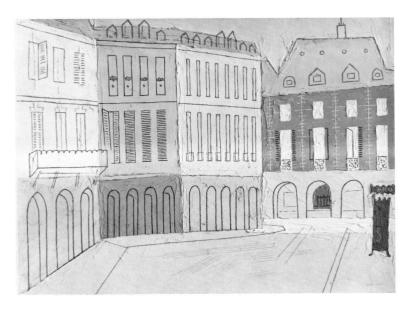

31

4. *Hotel Café*, 1928-1929

Lithograph on stone
Edition 30
10¼ × 7⅞ in. (26.0 × 20.0 cm)
Inscribed, l.l. on stone: "<u>STUART</u> DAVIS"

Amon Carter Museum impression on chine collé; inscribed, l.l. in graphite: (below image) "3/30", (bottom left corner of sheet in a different hand) "#5 Hotel Café"; l.r. in graphite: (below image) "Stuart Davis"; verso, l.l. three stamps: "DEC 4 1929"/"THE DOWN-TOWN GALLERY" "NOV 15 1935"

Cole 5 BIAA, CLEVE, MOMA
There are also four known artist's proofs.

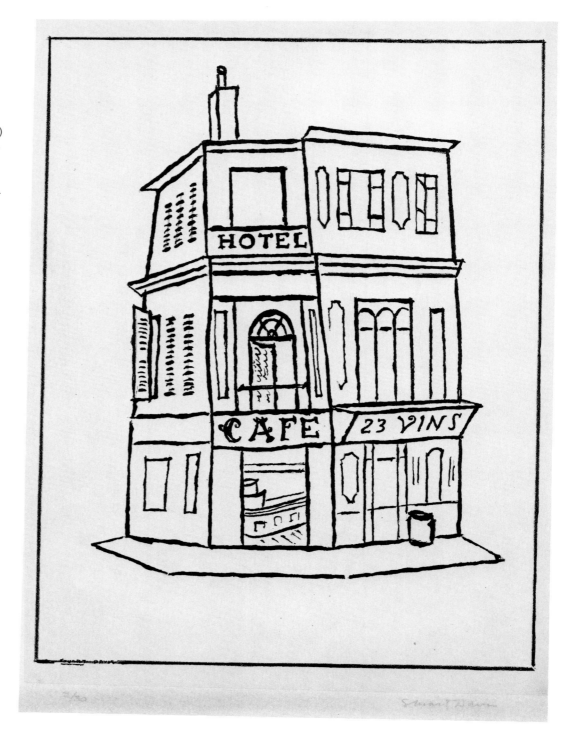

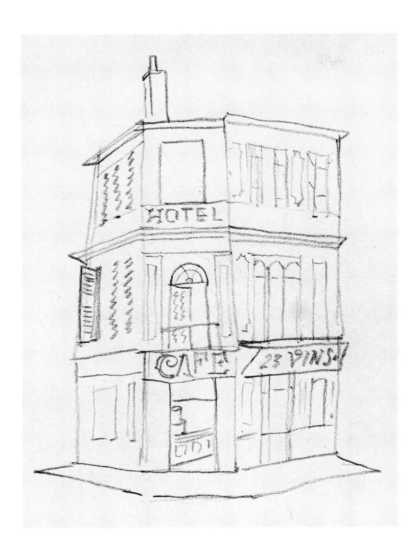

5. *Rue des Rats*, 1928-1929

Lithograph on stone
Edition 30
10 1/16 × 15 1/4 in. (25.6 × 38.7 cm)
Inscribed, l.r. on stone: "S.D."

Amon Carter Museum impression on chine collé; inscribed, l.l. in graphite: (below image) "2/30", (bottom left corner of sheet in a different hand) "#2 Rue des Rats"; l.r. in graphite: (below image) "Stuart Davis"; verso, l.l. two stamps: "NOV 15 1935" "THE DOWNTOWN GALLERY"; l.r. stamp: "JUN 29 1931"

Cole 6 FOGG, NMAA, NYPL, PMA
There are two impressions of *Rue des Rats* marked "2/30": in the collections of the Fogg Art Museum, Harvard University, and the Amon Carter Museum. There is one known unsigned and unnumbered proof. The location of the painting *Rue des Rats No. 1* (1928, formerly Herman Shulman) is unknown.

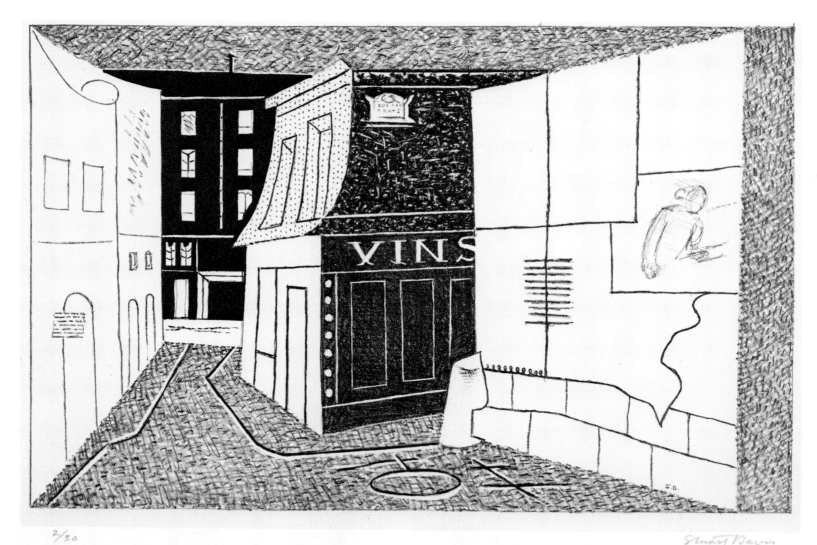

2/30 Stuart Davis

35

6. *Arch No. 1*, 1929

Lithograph on stone
Edition 30
8¹⁵⁄₁₆ × 12¹⁵⁄₁₆ in. (22.7 × 32.9 cm)

Amon Carter Museum impression on chine
collé; inscribed, l.l. in graphite: (below image)
"27/30", (bottom left corner of sheet in a
different hand) "#6 Arch"; l.r. in graphite:

(below image) "Stuart Davis"; verso, l.l.
stamp: "OCT 31 1930" [The Downtown
Gallery]

Cole 10 NORTON, SHELDON, UNM
There is one known artist's proof.
Two lost paintings also relate to this series:
Carrefour and *Porte St. Martin*.

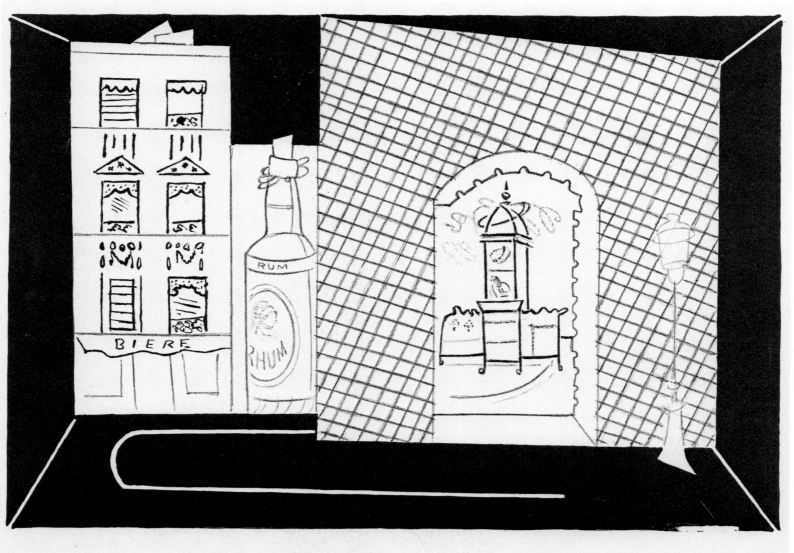

27/30 Stuart Davis

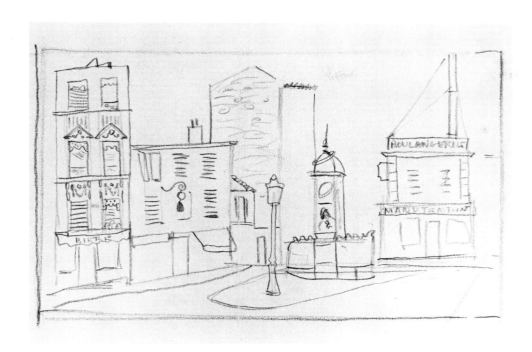

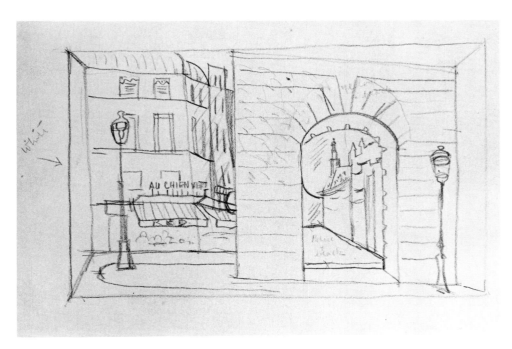

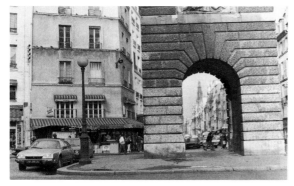

6a. (top left) *Sketchbook drawing, Paris,*
1928-1929, Graphite on paper, Amon
Carter Museum, Checklist no. 7

6b. (lower left) *Sketchbook drawing, Porte St.*
Martin, **1928-1929,** Graphite on paper,
Amon Carter Museum, Checklist no. 6

6c. (right) *Porte St. Martin;* Photograph
courtesy of Mr. and Mrs. J. H. Motes

7. *Arch No. 2*, 1929

Lithograph on stone
Edition 20
9⁷⁄₁₆ × 13³⁄₁₆ in. (24.0 × 33.5 cm)

Amon Carter Museum impression on chine collé; inscribed, l.l. in graphite: (below image)

"4/20", (bottom left corner of sheet in a different hand) "Arch #21"; l.r. in graphite: (below image) "Stuart Davis"; verso, l.l. three stamps: "OCT 31 1930"/"NOV 15 1935" "THE DOWNTOWN GALLERY"

Cole 11 GMA, HMSG

Two impressions of *Arch No. 2* are numbered "¹⁄₁₀" and "⁵⁄₁₀" while other impressions from the edition are numbered over "20."

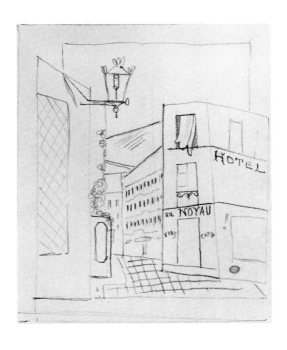

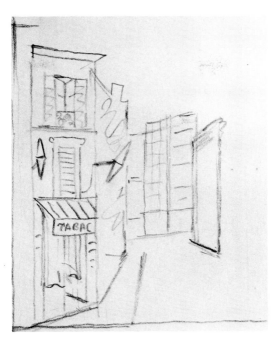

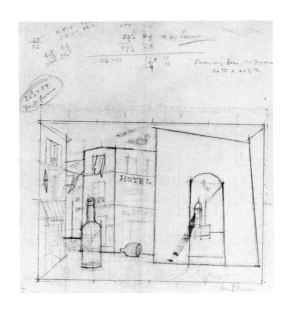

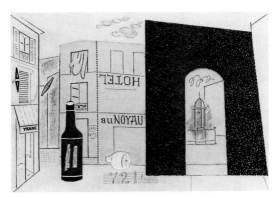

7a. (top left) *Sketchbook drawing, Paris, 1928-1929,* Graphite on paper, Amon Carter Museum, Checklist no. 8

7b. (top right) *Sketchbook drawing, Paris, 1928-1929,* Graphite on paper, Amon Carter Museum, Checklist no. 9

7c. (lower left) *Study for Arch No. 2, 1928-1929,* Graphite, orange crayon, and gouache on paper, Amon Carter Museum, Checklist no. 10

7d. (lower right) *Arch Hotel,* 1929, Oil on canvas, 28¾ × 39½ in., Sheldon Memorial Art Gallery, University of Nebraska-Lincoln, F. M. Hall Collection

8. *Au Bon Coin,* 1929

Lithograph on stone
Edition 30
7¹³⁄₁₆ × 9⅞ in. (19.8 × 25.1 cm)
Inscribed, u.l. on stone: "S.D."

Amon Carter Museum impression on chine
collé; inscribed, l.l. in graphite: (below image)
"1/30", (bottom left corner of sheet in a dif-
ferent hand) "#1 Au Bon Coin"; l.r. in
graphite: (below image) "Stuart Davis"

Cole 7 MOMA, RISD, UD, UKAM
There is also one known artist's proof.

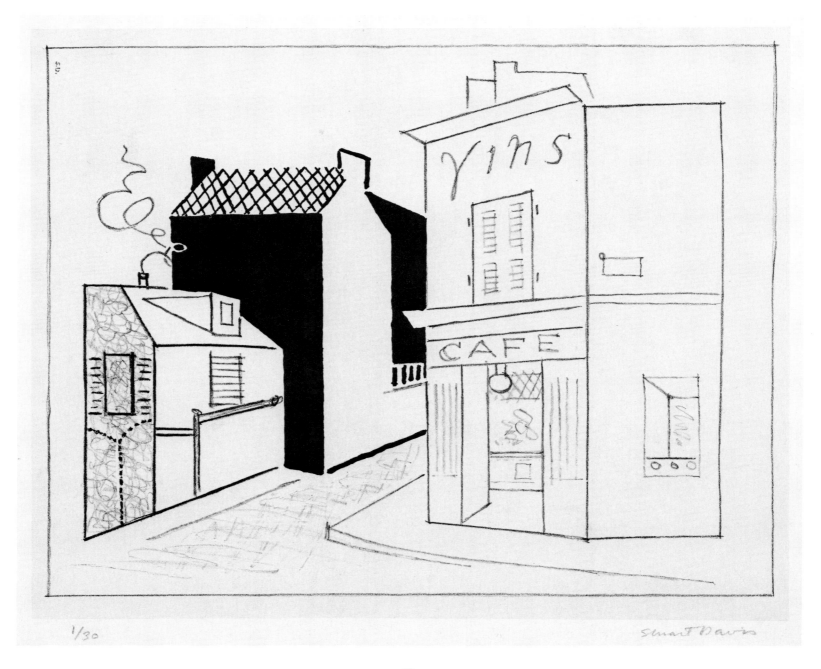

40

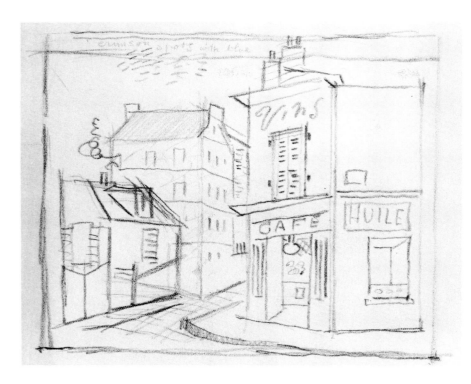

8a. (top) *Study for Au Bon Coin*, **1928-1929,** Graphite on paper, Amon Carter Museum, Checklist no. 11

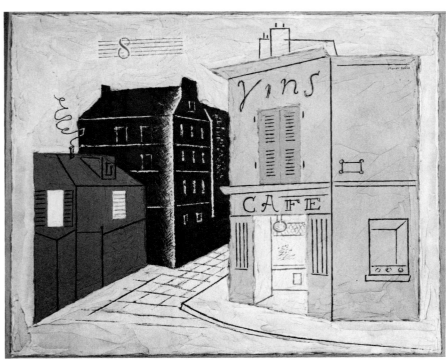

8b. (lower) *Blue Café*, **1928,** Oil on canvas, The Phillips Collection, Washington, D.C., Checklist no. 18

9. *Hotel de France*, 1929

Lithograph on stone
Edition 30
13⅞ × 11 in. (35.2 × 27.9 cm)
Inscribed, l.r. on stone: "STUART DAVIS"

Amon Carter Museum impression on chine collé; inscribed, l.l. in graphite: (below image) "1/30", (bottom left corner of sheet in a different hand) "#9 Hotel de France"; l.r. in graphite: (below image) "Stuart Davis"

Cole 4 GMA, WMAA
The location of the painting *Hotel de France* (1928, formerly Martin Schwab) is unknown.

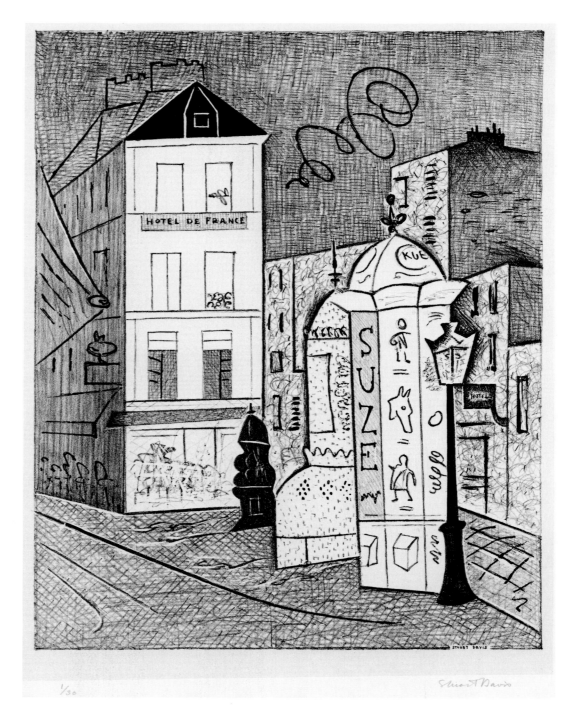

42

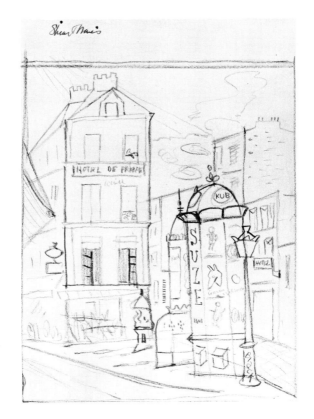

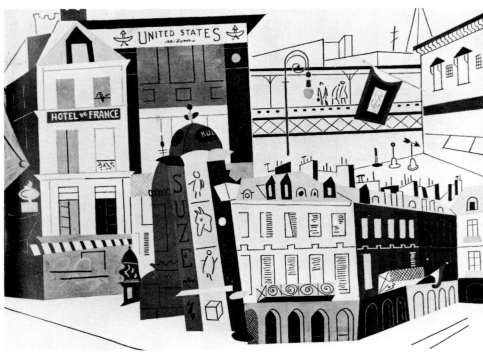

9a. (left) *Study for Hotel de France*, 1928,
Graphite on paper, Amon Carter Museum,
Checklist no. 2

9b. (right) *New York–Paris No. 2*, February
1931, Oil on canvas, Portland Museum of
Art, Portland, Maine; Hamilton Easter Field
Art Foundation Collection; Gift of Barn
Gallery Associates, Inc., Ogunquit, Maine,
1979, Checklist no. 22

10. *Place Pasdeloup No. 1*, 1929

Lithograph on stone
Edition 10
13¹¹⁄₁₆ × 11 in. (34.8 × 27.9 cm)
Inscribed, l.l. on stone: "STUART DAVIS"

Amon Carter Museum impression on chine
collé; inscribed, l.l. in graphite: (below image)
"6/10"; l.r. in graphite: (below image) "Stuart
Davis"

Cole 8 AIC, CI, MET

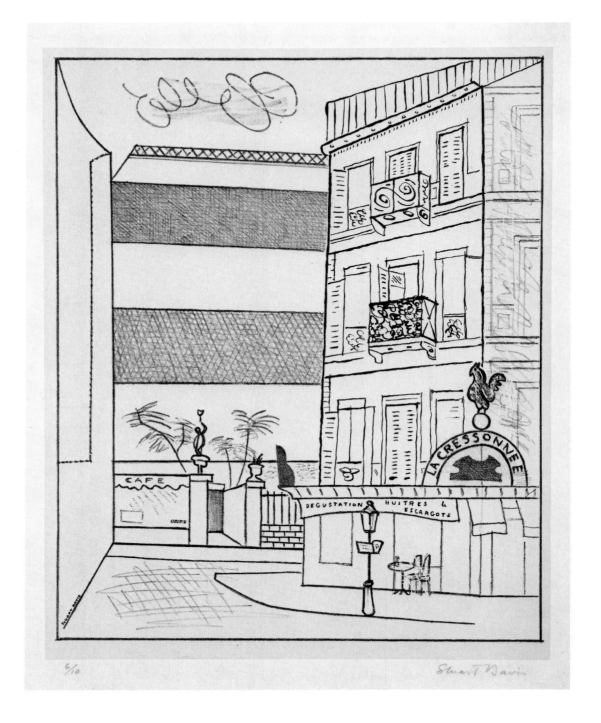

44

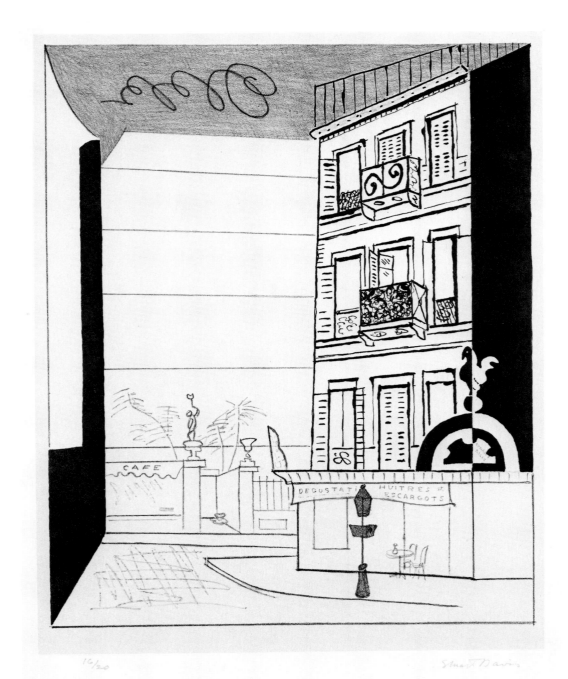

11. *Place Pasdeloup No. 2*, 1929

Lithograph on stone
Edition 20
13⁹/₁₆ × 10¹⁵/₁₆ in. (34.5 × 27.8 cm)
Inscribed, l.r. on stone: "STUART DAVIS"

Amon Carter Museum impression on chine
collé; inscribed, l.l. in graphite: (below image)
"16/20", (bottom left corner of sheet in a
different hand) "Place Pasdeloupe [sic]"; l.r.
in graphite: (below image) "Stuart Davis"

Cole 9 AGAA, CI, HIGH, MOMA, NYPL,
PC, UNM

11a. *Place Pasdeloup,* **1928,** Oil on canvas, Collection of Whitney Museum of American Art, New York; Gift of Gertrude Vanderbilt Whitney, Checklist no. 19

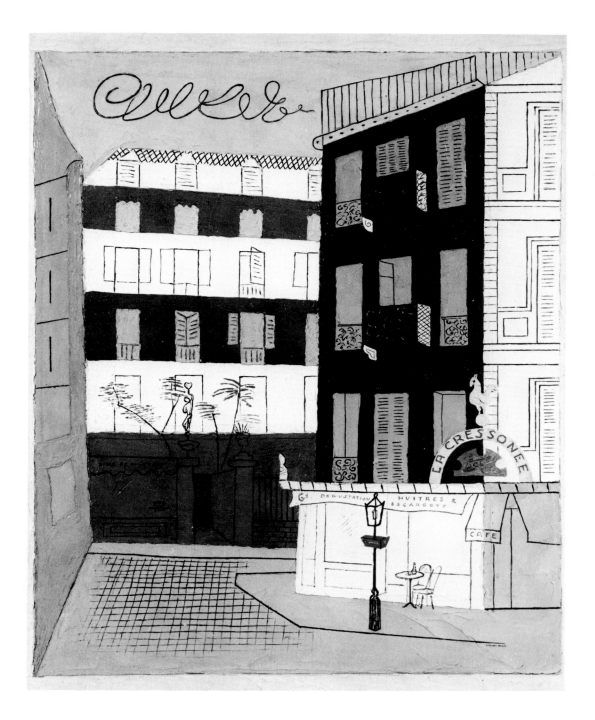

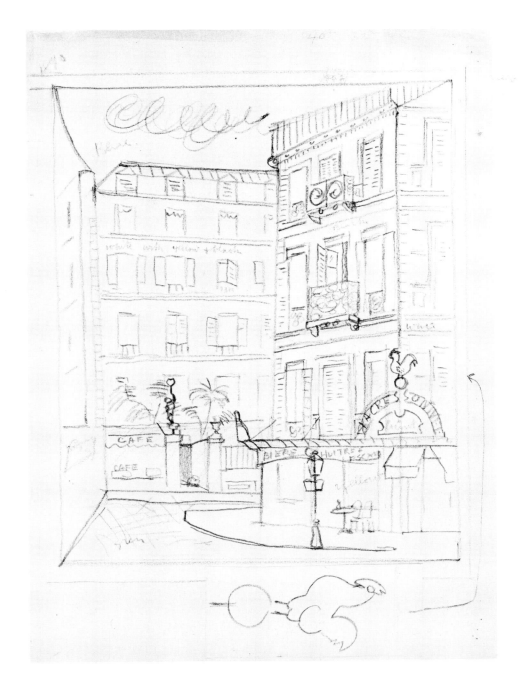

11b. *Study for Place Pasdeloup*, 1928,
Graphite on paper, Amon Carter Museum,
Checklist no. 3

11c. (right) *Place Pasdeloup;* Photograph
courtesy of Mr. and Mrs. J. H. Motes

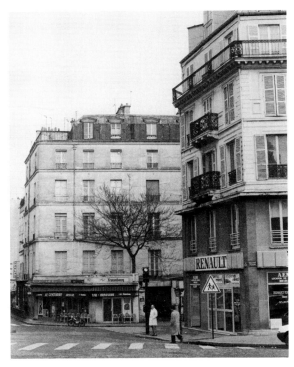

47

12. *Rue de l'Echaudé,* 1929

Lithograph on stone
Edition 30
9¹/₁₆ × 14¹/₁₆ in. (23.0 × 35.7 cm)
Inscribed, l.r. on stone: "STUART DAVIS"

Amon Carter Museum impression on chine collé; inscribed, l.l. in graphite: (below image) "2/30", (bottom left corner of sheet in a different hand) "#1 Rue Echaudé"; l.r. in graphite: (below image) "Stuart Davis"; verso, l.l. two stamps: "THE DOWNTOWN GALLERY" "NOV 15 1935"

Cole 12 GMA, MOMA, NMAA, WMAA
The location of the painting *Rue de l'Echaudé* (1929, formerly Mrs. Otto Spaeth) is unknown.

12a. (top) **Study for Rue de l'Echaudé, 1928-1929,** Graphite on paper, Amon Carter Museum, Checklist no. 13

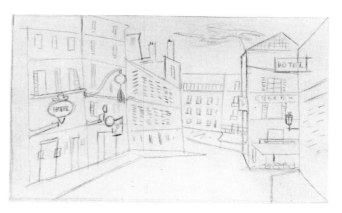

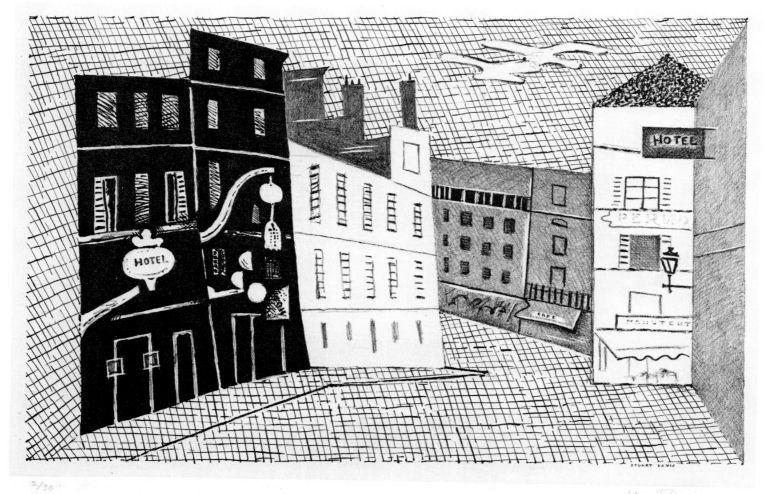

48

13. *Two Heads*, 1929

Lithograph (on stone ?)
Edition 12
9⁷⁄₁₆ × 12¼ in. (irreg.) (24.0 × 31.1 cm)
Inscribed, l.r. on stone: "SD"

Amon Carter Museum impression inscribed,
l.l. in graphite: (below image) "6/12"; l.r. in
graphite: (below image) "Stuart Davis";
verso, l.l. stamp: "JAN 28 1930"

Cole 13 MOMA, RISD

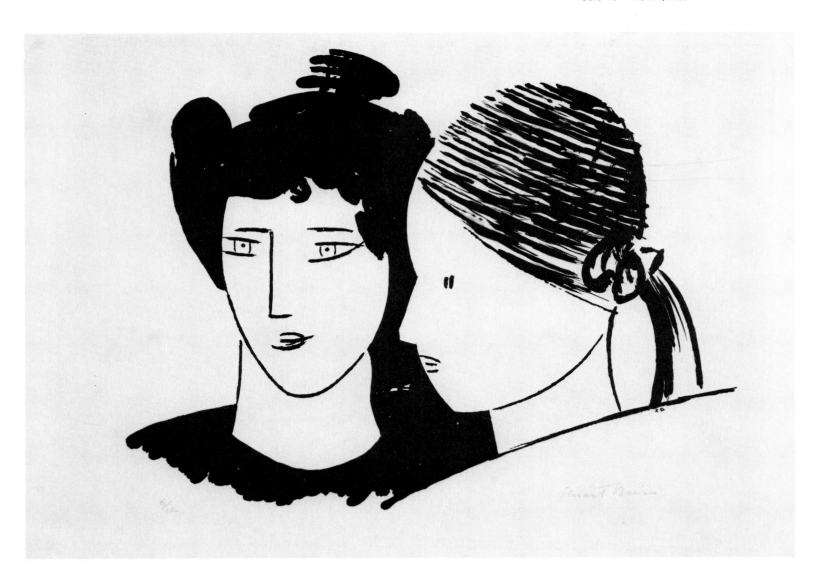

PRINTS: 1931

IN THE FIVE LITHOGRAPHS Davis produced following his trip to Europe, he once again returned to the American imagery of his early career and transformed indigenous urban and coastal subjects into a pictorial language incorporating both cubist and surrealist elements. The 1931 prints are tightly filled compositions replete with manifestations of the artist's richly visual environment.

The town of Gloucester, Massachusetts, where Davis spent his summers, figures prominently in two of the prints, *Barber Shop Chord* and *Theatre on the Beach*, whereas *Two Figures and El* and *Sixth Avenue El* were derived from drawings in the artist's New York sketchbooks. The fifth print, *Composition*, is the most abstract of the group, exhibiting only vestiges of naturalistic forms: an isolated arm and three vertical shapes in the center of the composition suggesting masts, among the many nautical subjects that engaged Davis during his Gloucester residences. Davis's repertoire of Gloucester motifs included the conically shaped natural gas tank that appears in the lithograph *Barber Shop Chord*.[1] Towering over sixty feet, the structure was one of two brick tanks (no longer standing) located along the Gloucester waterfront. These gas tanks were a prominent feature in the artist's youth as well, for in an early sketchbook dated 1909, Davis recorded similar gas houses in East Orange, New Jersey, where he lived with his family from 1901 to 1910.[2]

The lithographs of the 1931 period also summarize other themes in Davis's life and work. The biomorphic figures in *Two Figures and El* evince the dreamlike imagery of surrealism, a movement garnering considerable notice when Davis lived in France. One conspicuous component with specific origins in Davis's trip to Paris is the theater in *Theatre on the Beach*, a lithograph in which the Gloucester shore (in a configuration copied from one of Davis's summer sketchbooks) is incongruously situated beside an ornate theater. Superimposed over the two halves in a pose reminiscent of Picasso's grooming women is a cubist-inspired nude figure. The horizontal marks on the figure's torso and the position of the arms and hands simultaneously suggest the musician motif prevalent in the cubist iconography. The source for the theater building, which was also photographed in 1925 by Eugène Atget (1856-1927), lies in a Paris drawing. Davis elected to sketch only the central portion of the Théâtre de l'Atelier, located in the Montmartre district, and in the lithographed version, the artist further shortens the building to two bays and simplifies the architectural embellishment—an ornamental head relief—over each arched window.[3] One of these

stone medallions reappears in the lithograph *Sixth Avenue El*, where it has been transformed into a large, disembodied theatrical mask, contributing to the playful regrouping of disparate geographies and subjects characteristic of the 1931 prints.

Four of the prints from the 1931 period fall into two pairs. *Barber Shop Chord* and *Sixth Avenue El* were exhibited at the Downtown Gallery's American Print Makers annual exhibition in 1931, and *Theatre on the Beach* and *Two Figures and El* appeared in the same exhibition held two years later. Halpert's American Print Makers Annuals, instituted in 1927, were noteworthy because the selection committee, composed of prominent artists, invited printmakers to contribute selections of their choice from their print *oeuvre*. Thus, the printmakers could freely determine which prints would represent them. Unlike other participants in the Print Makers Annuals, Davis was not primarily a printmaker. Although the promotion of his lithographs by Edith Halpert through these regular exhibitions never translated into a market for his prints, the exposure provided Davis with some measure of critical acclaim as a printmaker.

The majority of the prints in the Print Makers Annuals were lithographs, a medium considered to represent innovative and modern trends, in contrast to the intaglio methods associated with the more traditional school. Critics applauded the avant-garde spirit embodied in the prints of Davis and other young artists, describing them as "thoroughly sensitive to the contemporary scene and to contemporary ideas in aesthetics."[4] Another writer praised their work as "exceedingly lively and vivacious.

Certain of them, such as Yasuo Kuniyoshi, Stuart Davis and Wanda Gag, have so much command of their medium that they give the effect of being unaware of their medium—and that is an ideal state for any artist to reach."[5] Davis's prints were singled out as "stirring abstractions,"[6] his *Barber Shop Chord*, "resonant."[7] Among the lithographers included in Halpert's exhibitions were artists such as Ashile Gorky and Max Weber whose work was experimental and abstract, as well as artists like John Steuart Curry whose work exemplified the conservative, regionalist idiom. Davis was clearly in the former camp and made a brief, but impressive, appearance in the print community of the early 1930s.

J.M.

1. The tanks also appear in Davis's *Gloucester Wharf* (1926-1935, gouache, pencil, and India ink on cardboard, Milwaukee Art Center). My thanks to Martha Oaks, Cape Ann Historical Association, Gloucester, Massachusetts, for providing information on Davis's Gloucester imagery.
2. This sketchbook is in the collection of Earl Davis.
3. Jean Cocteau's "Antigone," with sets by Picasso, was first performed at the Théâtre de l'Atelier in 1922. Philippe Jullian, *Montmartre*, tr. Anne Carter (Oxford: Phaidon Press, 1977), p. 195.
4. "Left Wing of American Print Makers, 36 Strong, Hold Annual," *Art Digest* 5, no. 6 (December 15, 1930): 23.
5. Henry McBride, "American Etchers and Lithographers," *New York Sun*, December 12, 1931, p. 12.
6. "American Print Makers: The Downtown Gallery," *Art News* 30 (December 12, 1931): 14.
7. Elisabeth Luther Cary, "The American Print Makers: Depth and Satire," *New York Times*, December 13, 1931, Section 8, p. 11.

14. *Barber Shop Chord*, 1931

Lithograph on zinc
Edition 25, plus five artist's proofs
13⅞ × 18⅞ in. (35.2 × 47.9 cm)
Inscribed, l.l. on the plate: "STUART DAVIS"

Amon Carter Museum impression inscribed,
l.l. in graphite: (below image) "1/25"; l.r. in
graphite: (below image) "Stuart Davis"

Cole 18 AIC, MET, MOMA, NMAA, NYPL,
OAC, PMA, UKAM, WMAA

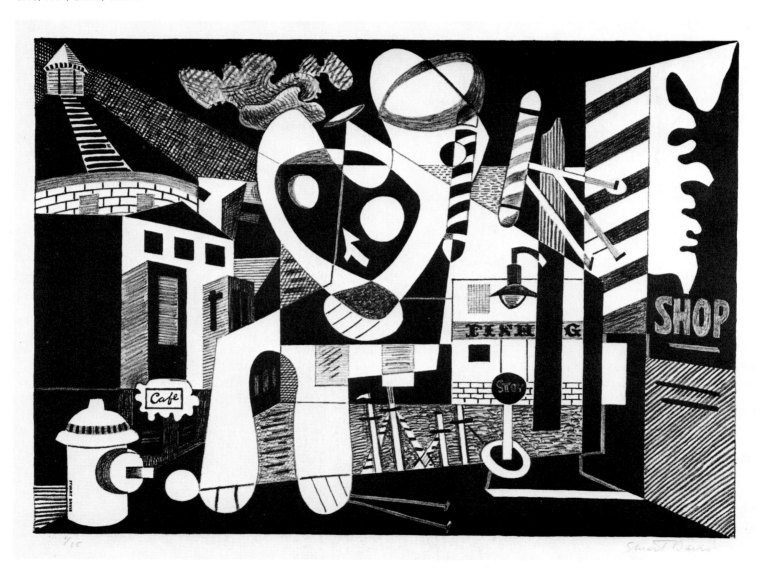

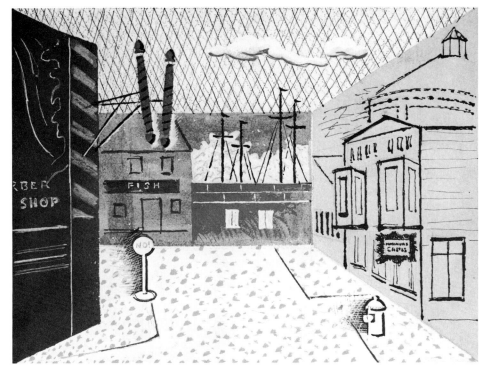

14a. (top) *New England Street*, c. 1929, Gouache on paper, 8¾ × 11¼ in., Collection of Whitney Museum of American Art, New York

14b. (lower) *Study for Barber Shop Chord*, 1931, Red crayon on paper, 14 × 18½ in., Private collection

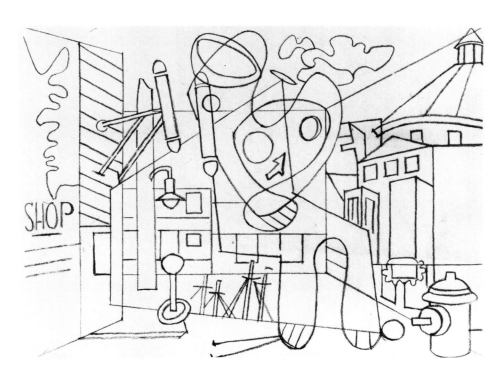

15. *Sixth Avenue El*, 1931

Lithograph on zinc
Edition 25, plus five artist's proofs
11⅞ × 17¹⁵⁄₁₆ in. (30.2 × 45.6 cm)
Inscribed, middle r. on the plate:
"STUART DAVIS"

Amon Carter Museum impression inscribed,
l.l. in graphite: (below image) "10/25", (bottom left corner of sheet in a different hand)

"#15 Sixth Avenue"; l.r. in graphite: (below image) "Stuart Davis"; verso, l.l. three stamps: "OCT 28 1931"/"THE DOWNTOWN GALLERY" "NOV 15 1935"

Cole 16 AIC, BRIT, LC, MCNAY, MOMA, PMA, WALKER, WMAA

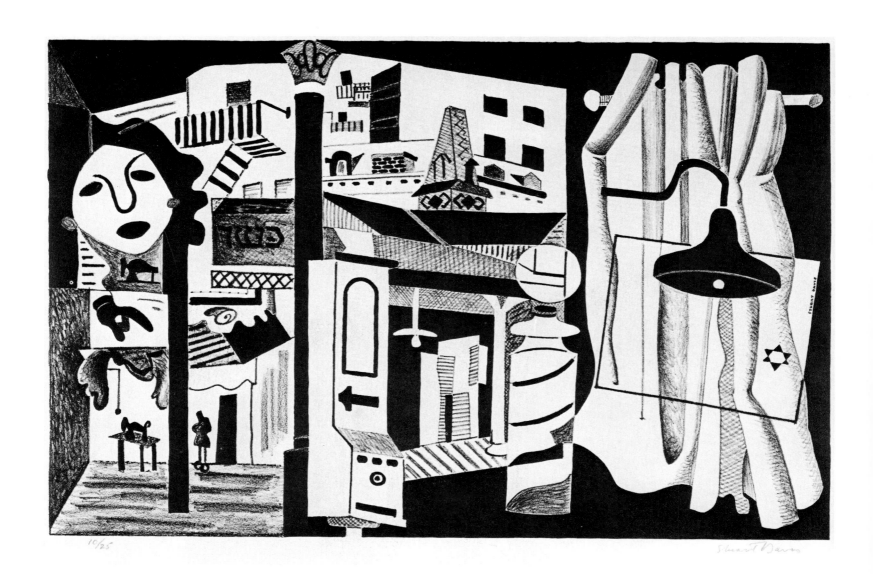

54

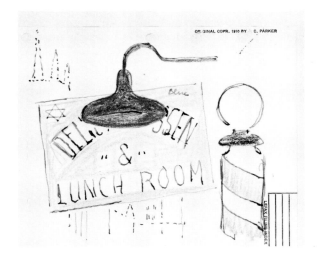

15a. (top left) *Sketchbook drawing*, 1926, Graphite on paper, 6¾ × 8¼ in., Collection of Earl Davis

15b. (top right) *Sketchbook drawing*, 1926, Graphite on paper, 6¾ × 8¼ in., Collection of Earl Davis

15c. (lower left) *Study for Sixth Avenue El*, c. 1931, Graphite on paper, 11¾ × 17¾ in., Citibank, N. A.

15d. (lower right) *Buildings and Figures*, c. 1931, Gouache on paper, 8¾ × 11¼ in., Collection of Mr. and Mrs. S. Roger Horchow

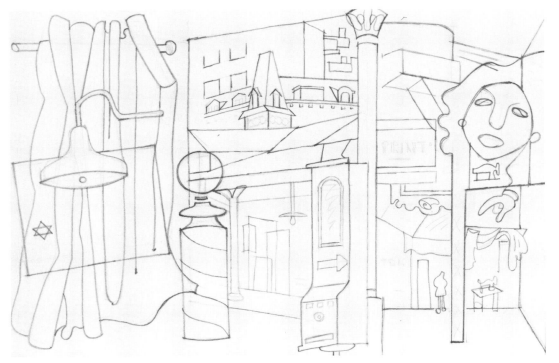

16. *Theatre on the Beach*, 1931

Lithograph on zinc
Edition 25, plus five artist's proofs
11 × 15 in. (27.9 × 38.1 cm)
Inscribed, l.l. on the plate: "SD"

Amon Carter Museum impression inscribed,
l.l. in graphite: (below image) "3/25"; l.r. in
graphite: (below image) "Stuart Davis"

Cole 15 SHELDON, WMAA

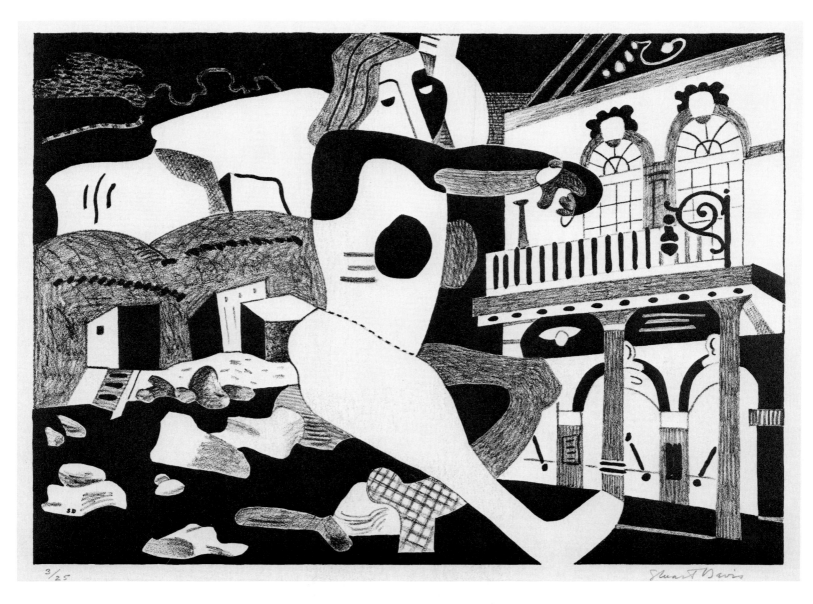

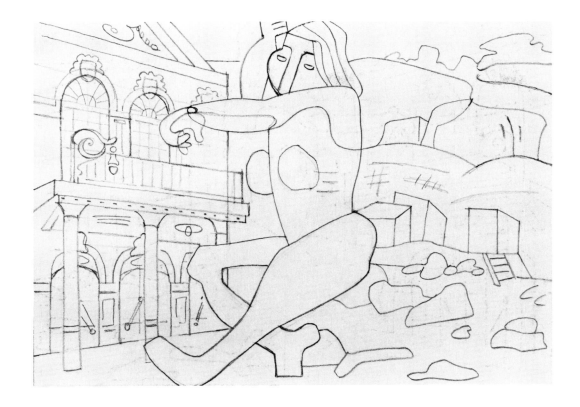

16a. (top) *Study for Theatre on the Beach*, **1931,** Graphite, orange crayon, and green crayon on paper, Amon Carter Museum, Checklist no. 15

16b. (lower left) *Study for Theatre on the Beach,* **1928-1929,** Graphite on paper, Amon Carter Museum, Checklist no. 14

16c. (lower right) Eugène Atget, *Place Dancourt, Théâtre de Montmartre, Juin 1925,* Gold-toned printing-out paper, 7 x 9⅜ in., Collection, The Museum of Modern Art, New York. The Abbott-Levy Collection. Partial gift of Shirley C. Burden.

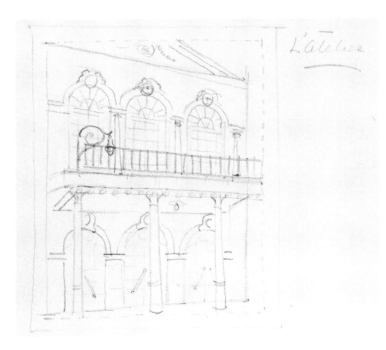

17. *Two Figures and El (Sixth Avenue El No. 2),* 1931

Lithograph on zinc
Edition 25, plus five artist's proofs
11 × 15 in. (27.9 × 38.1 cm)

Amon Carter Museum impression inscribed,
l.l. in graphite: (below image) "1/25"; l.r. in
graphite: (below image) "Stuart Davis"

Cole 17 BRIT, CORNELL, HIGH, LC, MEMR,
MFAB, UMMA, WMAA, YALE

17a. (lower) *Study for Two Figures and El,*
1931, Graphite on paper, Amon Carter
Museum, Checklist no. 16

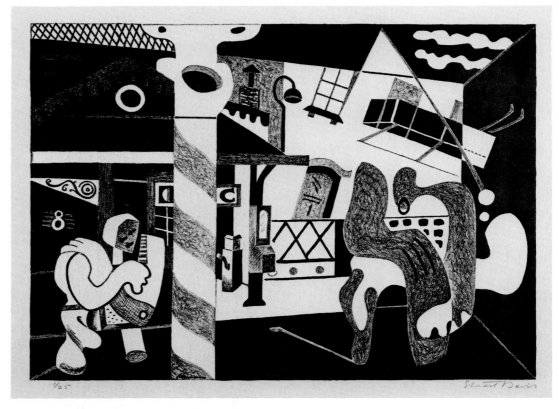

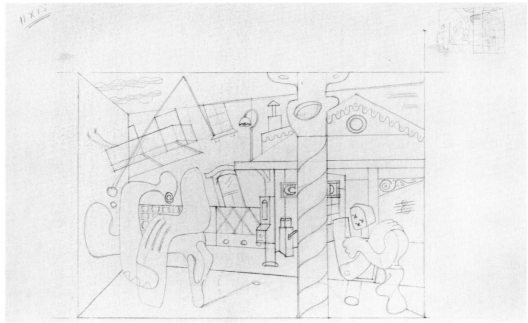

58

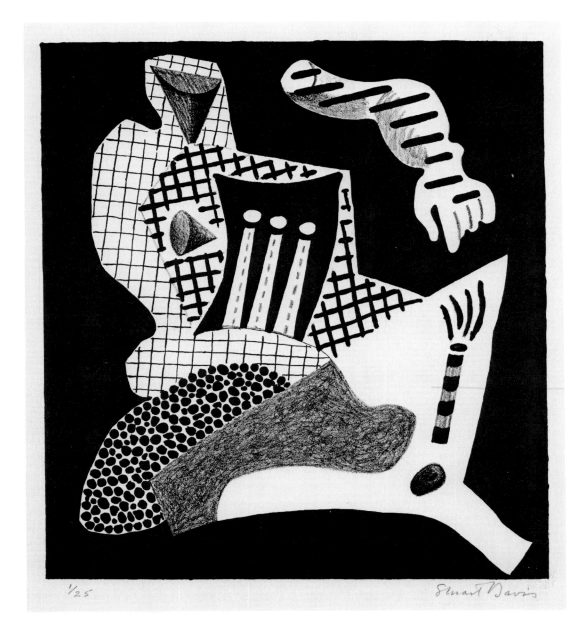

1/25

Stuart Davis

18. *Composition*, 1931

Lithograph on zinc
Edition 25, plus five artist's proofs
10 × 9 in. (25.4 × 22.9 cm)

Amon Carter Museum impression inscribed,
l.l. in graphite: (below image) "1/25", (bottom left corner of sheet in a different hand)
"Composition"; l.r. in graphite: (below image)
"Stuart Davis"

Cole 14 MOMA, UNM, WMAA

PRINTS: 1936-1939

DURING the mid to late 1930s, Stuart Davis made four lithographs, one in color. In 1936, Davis's lithograph *Anchor* was published by the American Artists School, an institution that had opened earlier that year at 131 West 14th Street, for the avowed purpose of "[making] the student conscious of his social and economic environment, and to instruct him in suitable methods for its presentation."[1] *Anchor* was one of several prints issued as part of a fund-raising effort by the School.[2] The prints, issued in two series, are marked on the verso with an ink stamp. Artists represented in the first edition included Harry Gottlieb, Eugene C. Fitsch, Raphael Soyer, Yasuo Kuniyoshi, and Davis. This project was so successful that in the fall of 1936, an announcement was made that Anton Refregier, David Alfaro Siquieros, Max Weber, Louis Lozowick, and Elizabeth Olds would publish a second set of prints, again for the benefit of the American Artists School, available for $10.00 per set.[3] Although they projected editions of 150, the actual edition size may have been only 100, as indicated by prints that bear the inscriptions "ed 100" or "only 100 printed." The printer for the School's annual series is unknown. It was perhaps Jacob Friedland who taught lithography at the School.[4]

Over a four-month period in 1939, Davis made three prints for the Graphic Arts Division of the Works Progress Administration. The WPA, organized in 1936, made expensive equipment available to printmakers and provided them with an opportunity to interact with other artists, the majority of whom undertook a more realistic approach to their subject matter than Davis did. In his three WPA prints, *Harbor Landscape, New Jersey Landscape*, and *Shapes of Landscape Space*, Davis employed imagery of the New York and Gloucester harbors as the basis for his compact compositions of interlocking elements: the rectilinear grid of ratlines, a ship's air vent and wheel, coiled ropes, and furled sails. By 1937, artists seeking the technical challenge could take advantage of the WPA's facilities for the production of color lithographs, most frequently, like Davis's *Shapes of Landscape Space*, executed in four colors. The revival of color lithography in the late 1930s, as artists experimented with the many nuances of printing in color, paved the way for Davis's few prints dating to the last twenty years of his life.

In his calendar (artist's estate) for 1939, Davis's notations outline the design and printing of the WPA lithographs. In May of that year, Davis made the initial design for *Shapes of Landscape Space* and sent it to the Project for approval. Later the same month he transferred the

design to the stone provided by the Project. In June, Davis began work on one of the two black and white lithographs and went to the Project's workshop to make the three color stones for *Shapes of Landscape Space*. The color lithograph was completed in July, the month in which he also made the second black and white lithograph. *Shapes of Landscape Space* was printed at the WPA workshop in August.

J. M.

1. "A New Art School," *Art Digest* 10, no. 10 (February 15, 1936): 26.
2. The School sold prints as late as December 1937 when their second annual Christmas exhibition and sale promoted original works of art for purchase. See *Prints* 8 (December 1937): 116-117. Sometime before 1939 the School seems to have been dissolved.
3. *Prints* 7 (October 1936): 55.
4. Max Weber's contribution to the series, *Barrére Wind Orchestra* was printed by George Miller. Daryl R. Rubenstein, *Max Weber: A Catalogue Raisonné of His Graphic Work* (Chicago and London: The University of Chicago Press, 1980), p. 141.

19. *Anchor*, 1936

Lithograph on stone
Edition 100
8½ × 12⅞ in. (irreg.) (21.6 × 32.7 cm)
Inscribed, l.l. on stone: "SD"

Amon Carter Museum impression inscribed,
l.l. in graphite: (below image) "100 Ed"; l.r. in
graphite: (below image) "Stuart Davis";
verso, l.r. stamp: "FIRST ANNUAL PRINT
SERIES/1936/Issued by the/AMERICAN
ARTISTS SCHOOL/131 WEST FOUR-
TEENTH STREET/NEW YORK CITY"

Cole 19 DIA, LC, NMAA, PSU,
UMMA, UNM

A few impressions of *Anchor*, including the
Amon Carter Museum's print, bear a graph-
ite signature. The majority of the impres-
sions, however, bear a signature on the
stone ("Stuart Davis") in the lower right that
was added later to the image.

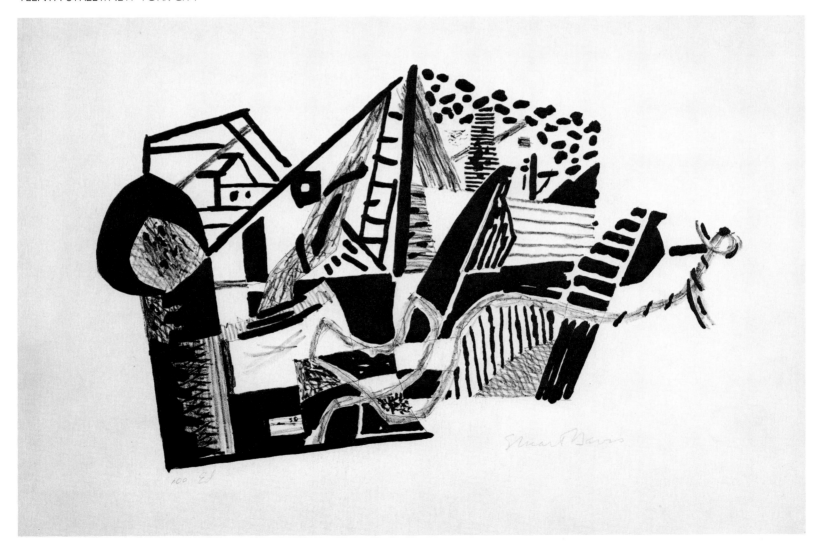

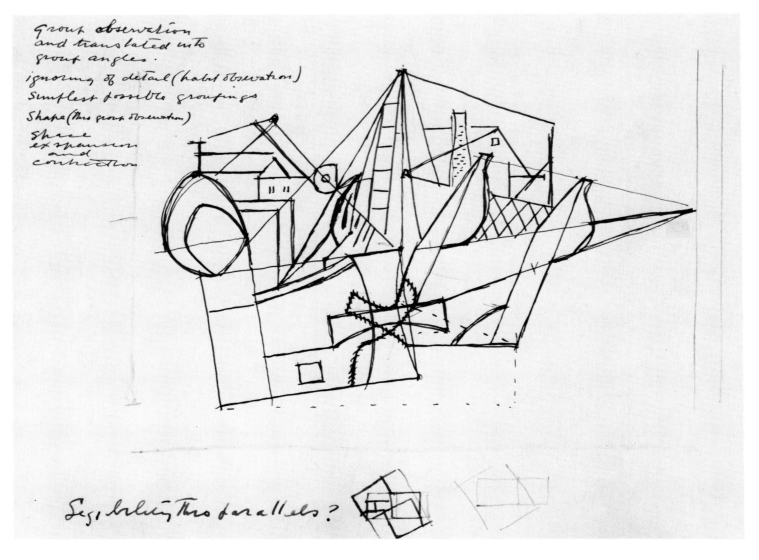

20. *Harbor Landscape (Funnel and Smoke), 1939*

Lithograph on stone
9⁵⁄₁₆ × 12¹³⁄₁₆ in. (23.7 × 31.0 cm)
Inscribed, l.r. on stone: "STUART DAVIS '39"; l.l. and l.r. on stone "MAT"

Amon Carter Museum impression, l.l. stamp: (bottom left corner of sheet) "FEDERAL ART PROJECT/NYC WPA"

Cole 21 BALT, DIA, IOWA, MET, NEWARK, NMAA, PMA, SHELDON

The edition size of Davis's three prints executed for the Works Progress Administration is not known. The WPA prints, however, were generally issued in editions of twenty-five, with three to six artist's proofs.

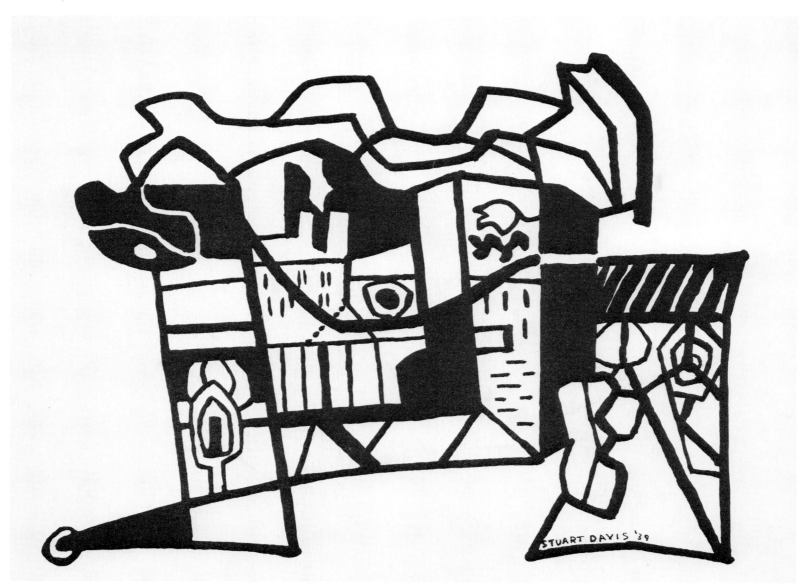

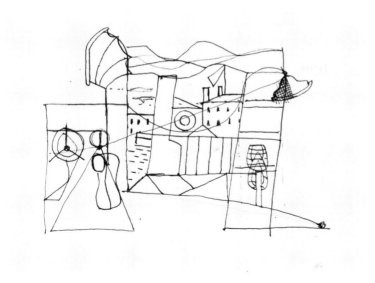

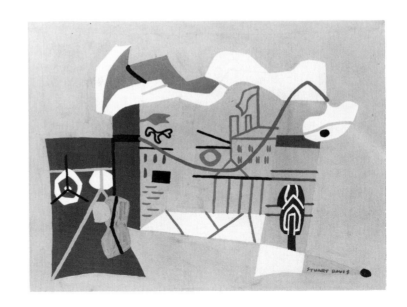

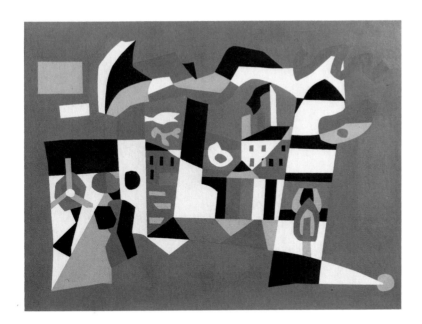

20a. (top left) *Study for Harbor Landscape*, **1932,** Graphite on paper, 8 x 10¼ in., Collection of Earl Davis

20b. (top right) *Colors of Spring in the Harbor*, **1939,** Gouache on watercolor board mounted on cardboard, 12 x 16 in., Collection of Munson-Williams-Proctor Institute Museum of Art, Utica, New York

20c. (lower left) *Midi,* **1954,** Oil on canvas, Wadsworth Atheneum, Hartford, Connecticut, The Henry Schnakenberg Fund, Checklist no. 24

21. *New Jersey Landscape (Seine Cart),*
1939

Lithograph on stone
7⁹⁄₁₆ × 13⁷⁄₁₆ in. (19.2 × 34.2 cm)
Inscribed, l.r. on stone: "STUART DAVIS
'39"

Amon Carter Museum impression, u.r.
stamp: "FEDERA [L ART PROJECT] / NYC
W[PA]"

Cole 20 BALL, CWMFA, IUAM, MET,
NEWARK, NYPL, PU
Edition, see catalogue raisonné number 20.

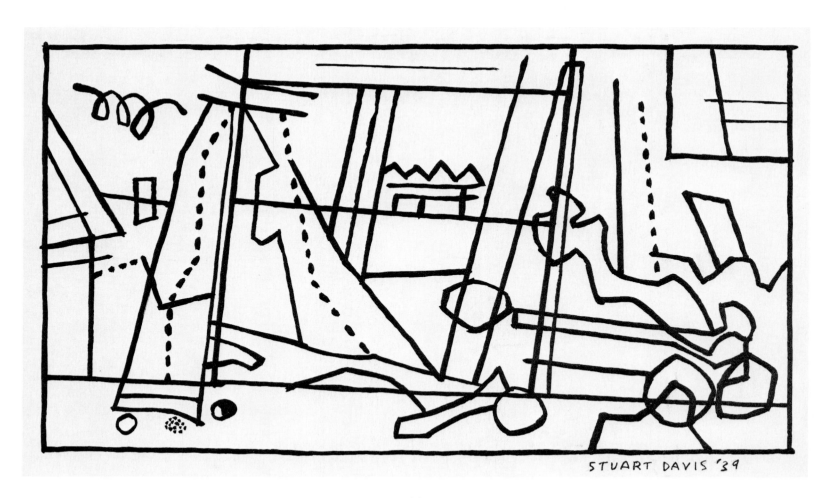

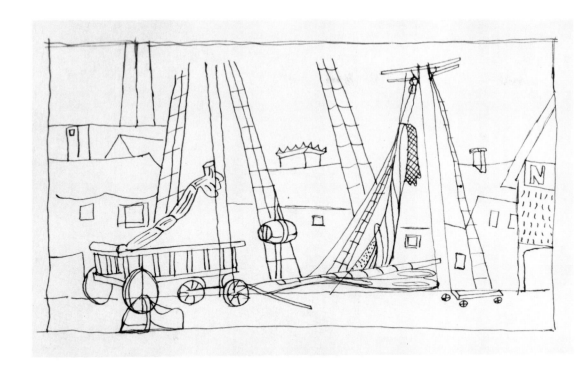

21a. (top) *Study for New Jersey Landscape,* **c. 1931-1932,** Graphite on paper, 10¾ × 14½ in., Collection of Earl Davis

21b. (lower) *Red Cart,* **1932,** Oil on canvas, 32 × 50 in., Addison Gallery of American Art, Phillips Academy, Andover, Massachusetts

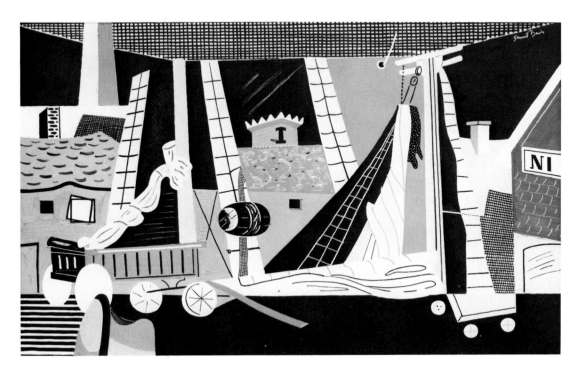

22. *Shapes of Landscape Space (Land-scape Space No. 4), 1939*

Lithograph on stone, printed in 4 colors
12⅝ × 9¹³⁄₁₆ in. (32.1 × 24.9 cm)
Inscribed, l.r. on stone: "STUART DAVIS"

Amon Carter Museum impression inscribed, l.r. in graphite: "To George - Stuart"*; l.r. in ink: (below image) "CUT MAT TO THESE MARKS"; l.l. stamp: (bottom left corner of sheet) "FEDERAL ART PROJECT/NYC WPA"

Cole 22 BALL, BALT, MOMA, NEWARK, SHELDON, UWM
Edition, see catalogue raisonné number 20.
 *Davis inscribed this print for his friend, jazz musician, George Wettling (1907-1968).

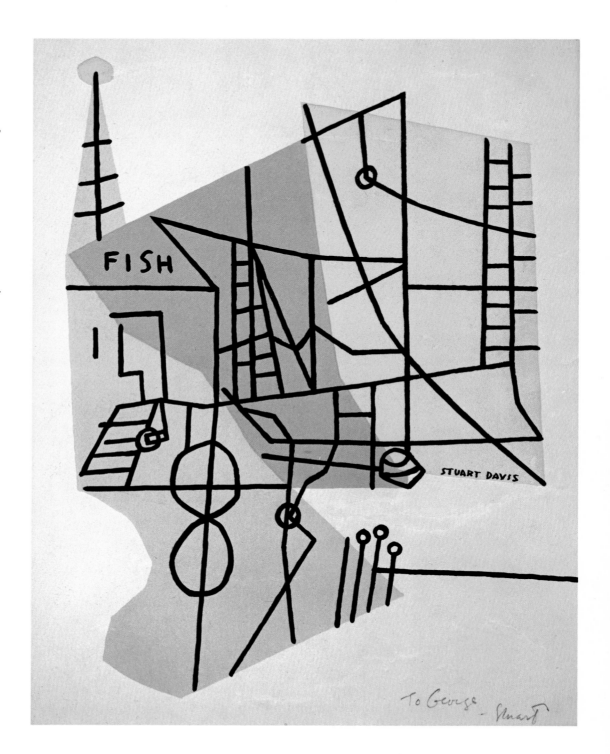

22a. (top) *Shapes of Landscape Space*, 1939, Tempera on paper, 14 × 10 in., University of Oklahoma Museum of Art

22b. (lower) *Study for Landscape*, 1932, Ink and graphite on paper, 7⅝ × 10 in., Collection of Earl Davis

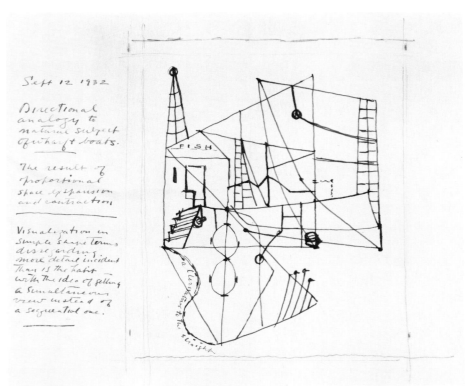

22c. (left) *Shapes of Landscape Space*, 1939,
Oil on canvas, 36 × 28 in., Neuberger
Museum, State University of New York at
Purchase; Gift of Roy R. Neuberger

22d. (right) *Memo*, 1956, Oil on canvas,
National Museum of American Art,
Smithsonian Institution; Gift of The Sara
Roby Foundation, Checklist no. 26

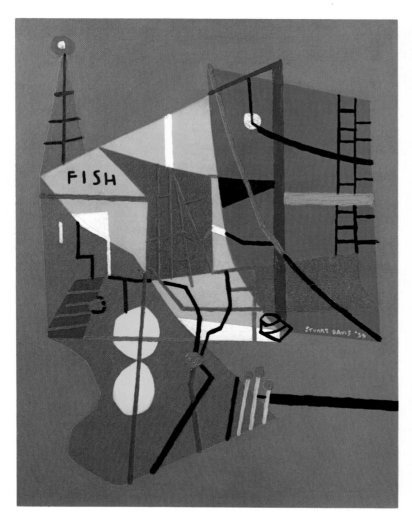

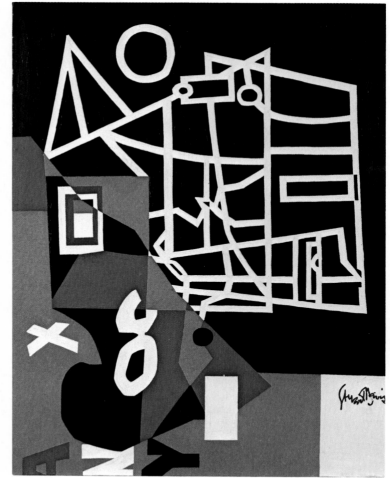

70

22e. (left) *Landscape,* **1932 and 1935,** Oil on canvas, 32½ x 29¼ in., The Brooklyn Museum; Gift of Mr. and Mrs. Milton Lowenthal

22f. (right) *Tournos,* **1954,** Oil on canvas, 35⅞ x 28 in., Collection of Munson-Williams-Proctor Institute Museum of Art, Utica, New York

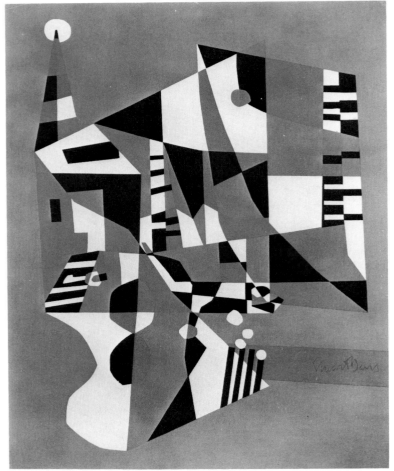

PRINTS: 1941-1964

THE PRINTS produced between 1941 and 1964 consisted of one color lithograph and four serigraphs in which the flat, unmodulated shapes and bold colors found in Davis's paintings were translated into print form. Around 1938, the new medium of serigraphy underwent serious artistic scrutiny as printmakers on the government payroll experimented with the silkscreen process at the workshop operated by the Works Progress Administration. The earliest of Stuart Davis's silkscreens, *Bass Rocks*, was published by an art dealer, Jack C. Rich, as part of his Contemporary American Painters Series. The print was the fifth version of the subject in a series of two paintings and two gouaches.[1] A drawing dating to the summer of 1938 is clearly the genesis for the cryptic, linear pattern describing the rocky outcropping that faces the ocean on the northeasterly side of Cape Ann, Massachusetts. In the print, Davis's subjectively flattened image is defined by colors that do not precisely reproduce those in any of the paintings or the gouaches, indicating the artist's fascination with modulating the color scheme.

In December of 1954, Davis made a gouache, *Study for a Drawing*,[2] and upon its completion he contacted Richard Miller of the Tiber Press about making a silkscreen after the work. Although a gouache by this title has not been identified, the print shares the configuration of a gouache in the collection of the Rose Art Museum, Brandeis University. The colors of this gouache are blue, white, and orange/red, rather than the blue, white, and red of the silkscreen. *Study for a Drawing* was printed in January 1955 by Floriano Vecchi of the Tiber Press.

The color lithograph *Detail Study for Cliché* of 1957 was based on the configuration that appears in the lower half of two paintings dating to 1955, *Cliché* (Solomon R. Guggenheim Museum) and *Ready to Wear* (The Art Institute of Chicago). A related gouache (private collection) and drawing (Collection of Earl Davis) identical in size to the print, also dating to 1955, likely served as preparatory studies for the lithograph.[3] On the recommendation of Arnold Singer, printer at The Pratt-Contemporaries Graphic Art Center, a workshop established in 1955 by Margaret Lowengrund, Davis was invited to participate in Lowengrund's Master Print series.[4] Davis elected to draw his design on zinc in his own studio, then transported it to Pratt where it was printed by Singer. Singer recalls that Davis had a sophisticated color sense and was particular about the colors, mixing them himself, taking many proofs before he was satisfied with the result. This collage-like print was made into a commemorative United States postage stamp in December 1964. The artist approved the final design for the stamp shortly before his death.[5]

Davis was involved to a considerably lesser degree in the execution of the two serigraph reproductions, *Ivy League*, printed by Tiber Press in 1953, and *Composition*, published in 1964 by the Wadsworth Atheneum, Hartford, Connecticut. Davis's calendar relates that Edith Halpert asked to use his 1953 gouache, *Ivy League*, on exhibit in her gallery that fall, as a Christmas card. It is doubtful that Davis supervised production of this print, and each impression has a screened signature. *Composition* was made after a 1962 casein drawing titled *Thermos* (Collection of Earl Davis), identical in size and color to the serigraph. The print was issued in the Wadsworth Atheneum's portfolio, *Ten Works/Ten Painters*, designed and produced by Norman Ives and Si Sillman, New Haven, Connecticut. Other artists represented in the edition were George Ortman, Frank Stella, Ellsworth Kelly, Robert Motherwell, Andy Warhol, Roy Lichtenstein, Larry Poons, Robert Indiana, and Ad Reinhardt. The idea for the portfolio of silkscreen prints was conceived by Samuel J. Wagstaff, Jr., then curator of the Wadsworth Atheneum, who obtained Davis's casein drawing through Edith Halpert. Davis died before the portfolio was published and was not able to approve the printing of the serigraph.

Silkscreen reproductions after three of Davis's paintings were also made during his lifetime by Esther Gentle in editions of about fifty. The titles and their image sizes are *Pad No. 4* (14³⁄₁₆ × 18⁵⁄₁₆ in.), *Report from Rockport* (24¼ × 30¼ in.) and *Hot Still-Scape for Six Colors—7th Avenue Style* (dimensions unknown).

J.M.

1. In a statement prepared for the Contemporary American Painters Series, Davis described his theories of composition and color as they relate to *Bass Rocks*. Reprinted in Diane Kelder, ed., *Stuart Davis: A Documentary Monograph* (New York, Washington, and London: Praeger Publishers, 1971), pp. 99-100.
2. Davis records the creation of the gouache and silkscreen in his 1954 calendar (Collection of Earl Davis).
3. The gouache is illustrated in *Art in America* 73 (April 1985), p. 20. The drawing is illustrated in Karen Wilkin and William C. Agee., *Stuart Davis (1892-1964): Black and White* (New York: Salander-O'Reilly Galleries, 1985), fig. 11.
4. Interview with Arnold Singer, August 22, 1985.
5. Discussions of the commission for the United States postage stamp include John Ross, "A Salute to the Fine Arts and Stuart Davis," *Artist's Proof* 8 (1965): 2-4, and "Footnotes: A New U.S. Stamp," *American Artist* 28 (December 1964): 8.

23. *Bass Rocks*, 1941

Serigraph
Edition 100
8⁷⁄₁₆ × 11⁷⁄₈ in. (21.4 × 30.2 cm)
Inscribed, l.r. in image: "STUART DAVIS '39"

Amon Carter Museum impression inscribed, l.l. in graphite: (below image) "Stuart Davis"

Cole 24 BALT, CIN, DAM, IMA, PAFA, PAM
The date that appears on the print, 1939, refers to the date of the painting, *Bass Rocks No. 1*, on which the print was based. Other works in the series, all dating to 1939, are *Bass Rocks No. 2* (private collection), and two gouache drawings in the collections of the Everson Museum of Art, Syracuse, New York (8¾ × 11½ in.) and the Whitney Museum of American Art, New York (9 × 12 in.).

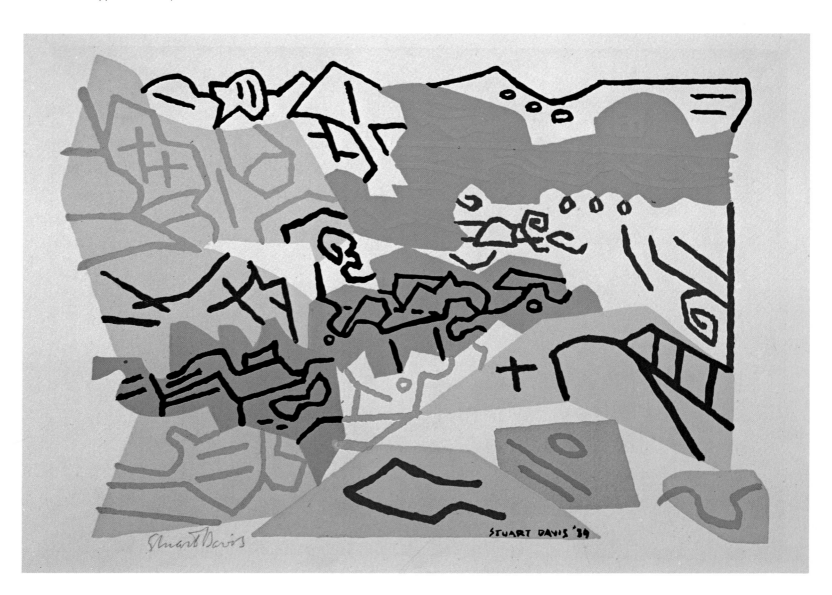

74

23a. (top) *Study for Bass Rocks*, 1938, Ink on paper, Amon Carter Museum, Checklist no. 17

23b. (lower) *Bass Rocks No. 1*, 1939, Oil on canvas, Courtesy Wichita Art Museum, the Roland P. Murdock Collection, Checklist no. 23

24. *Detail Study for Cliché,* 1957

Color lithograph on zinc, printed from three plates
Edition 40
12⅝ × 14¾ in. (32.1 × 37.5 cm)

Amon Carter Museum impression inscribed, l.l. in ink: (below image) "Artists proof", (bottom left corner of sheet in a different hand) "Detail Study for Cliché"; l.r. in ink: (below image) "Stuart Davis"

Cole 23 BIAA, BROOK, CIN, LC, MET, PMA, SHELDON, SMITH, WALKER

In addition to the edition, there are two known artist's proofs.

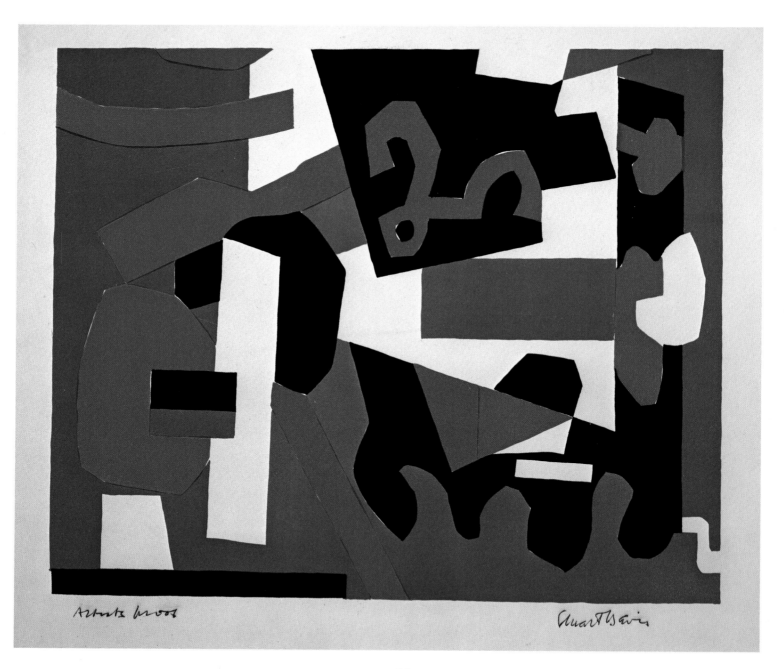

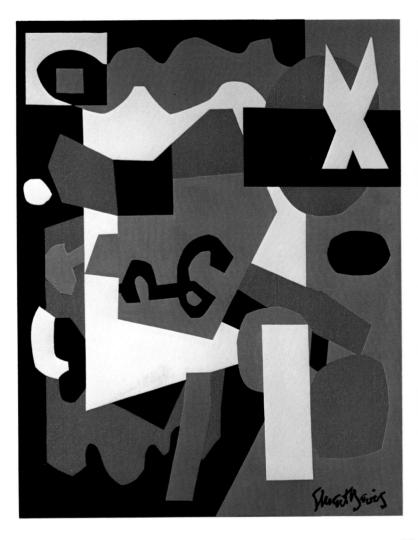

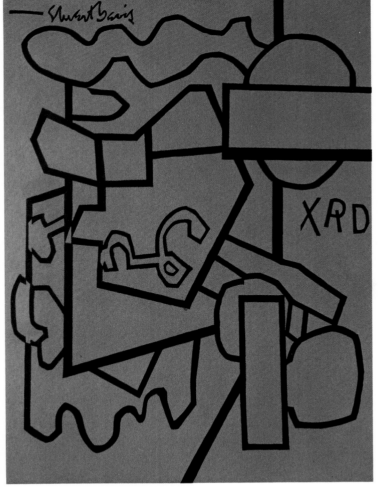

24a (top) *United States Postage Stamp*, **1964,** 1 x 1 9/16 in., Amon Carter Museum

24b. (left) ***Ready to Wear***, **1955,** Oil on canvas, 56 1/4 x 42 in., Sigmund W. Kunstadter Gift and Goodman Fund, The Art Institute of Chicago

24c. (right) ***Cliché***, **1955,** Oil on canvas, Solomon R. Guggenheim Museum, New York, Checklist no. 25

25. *Study for a Drawing*, 1955

Serigraph
Edition 100
7⅜ × 7¹¹/₁₆ in. (18.7 × 19.5 cm)

Amon Carter Museum impression inscribed,
l.l. in graphite: "35/100"; l.r. in graphite:
"Stuart Davis"

Cole 25

The artist numbered and signed about forty
impressions of *Study for a Drawing*. Of the
remaining prints in the edition, some bear a
stamped facsimile signature and are initialed
by Roselle or Earl Davis, the artist's wife and
son.

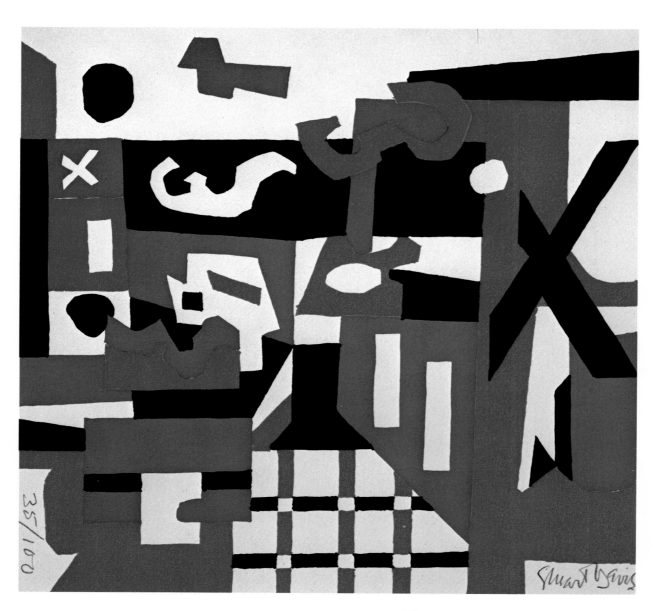

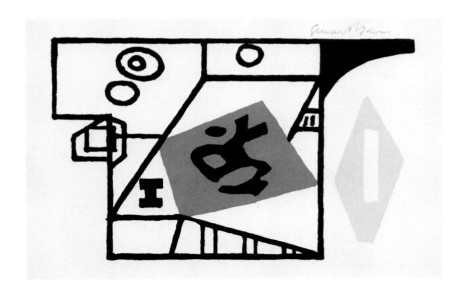

PRINTS AFTER STUART DAVIS

Ivy League, 1953

Serigraph
$4^{15}/_{16}$ × $7^{7}/_{8}$ in. (irreg.) (12.5 × 20.0 cm)
Inscribed, u.r. stencil: "Stuart Davis"
Cole 26

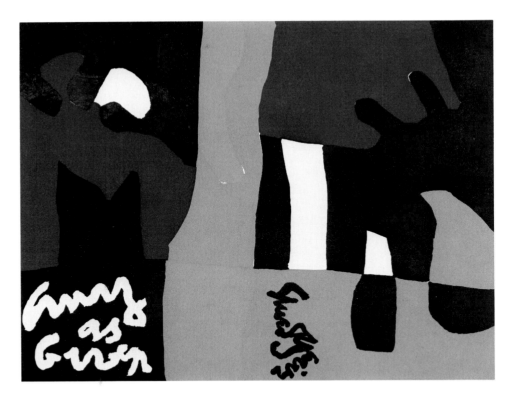

Composition, 1964

Serigraph
Edition 500
$11^{1}/_{16}$ × $14^{1}/_{8}$ in. (28.1 × 35.9 cm)
Inscribed, l.c. in image: "Stuart Davis";
l.r. printer's chopmark
Cole 27

EXHIBITION CHECKLIST

THIS CHECKLIST records works by Stuart Davis included in the exhibition at the Amon Carter Museum. Unless otherwise indicated, works are in the permanent collection of the Museum. In general, only primary inscriptions (i.e., signature, title, date) are included.

PRINTS

One etching in the collection of the National Museum of American History, Smithsonian Institution, and twenty-six lithographs and serigraphs in the Amon Carter Museum collection (see catalogue raisonné).

DRAWINGS

1. *Study for Adit*, 1928 (Fig. 2a)
GRAPHITE ON PAPER
Sheet: 9¼ × 5⅝ in. (23.5 × 14.3 cm)
Comp.: 5⅝ × 4½ in. (14.3 × 11.4 cm)
Inscribed, l.r. in graphite: "64 × 74/65 × 75"
The numerals inscribed on this drawing probably refer to the dimensions (in centimeters) of the two paintings *Industry* and *Adit No. 2* for which this drawing served as a study.

2. *Study for Hotel de France*, 1928 (Fig. 9a)
GRAPHITE ON PAPER
Sheet: 12⅜ × 9¹/₁₆ in. (31.4 × 23.0 cm)
Comp.: 9⅝ × 7½ in. (24.5 × 19.1 cm)
Inscribed, u.l. in ink: "Stuart Davis"

3. *Study for Place Pasdeloup*, 1928 (Fig. 11b)
GRAPHITE ON PAPER
Sheet: 12⁵/₁₆ × 9 in. (31.3 × 22.9 cm)
Comp.: 9½ × 7½ in. (24.1 × 19.1 cm)
Inscribed, u.l. in graphite: "1840";
u.r. in graphite: "40² 32 [illeg.]"

4. *Study for Place des Vosges*, 1928 (Fig. 3b)
GRAPHITE ON PAPER
Sheet: 8⅞ × 12⅜ in. (22.5 × 31.4 cm)
Comp.: 6¹³/₁₆ × 9¹⁵/₁₆ in. (17.3 × 25.2 cm)
Inscribed, u.r. in graphite: "Place de [*sic*] Vosges"
This is a preparatory drawing for the painting *Place des Vosges No. 2* (checklist no. 20). A similar drawing in the artist's estate (fig. 3c) served as a study for the painting, *Place des Vosges No. 1*.

5. *Study for Rue des Rats*, 1928 (Fig. 5a)

GRAPHITE ON PAPER

Sheet: 10⁹⁄₁₆ × 15⁹⁄₁₆ in. (26.8 × 39.5 cm)

Comp.: 6¹⁵⁄₁₆ × 10⁵⁄₁₆ in. (17.6 × 26.2 cm)

6. *Sketchbook drawing, Porte St. Martin*, 1928-1929
(Fig. 6b)

GRAPHITE ON PAPER

Sheet: 7¾ × 12⁷⁄₁₆ in. (19.7 × 31.6 cm)

Comp.: 6 × 9 in. (15.2 × 22.9 cm)

This drawing served as a study for the lithographs *Arch No. 1* and *Arch No. 2* and for the painting *Porte St. Martin* (location unknown).

7. *Sketchbook drawing, Paris*, 1928-1929 (Fig. 6a)

GRAPHITE ON PAPER

Sheet: 9 × 12⅜ in. (22.9 × 31.4 cm)

Comp.: 5⅞ × 9⅞ in. (14.9 × 25.1 cm)

This drawing served as a study for the lithograph *Arch No. 1* and for the painting *Carrefour* (location unknown).

8. *Sketchbook drawing, Paris*, 1928-1929 (Fig. 7a)

GRAPHITE ON PAPER

Sheet: 12⅜ × 9 in. (31.4 × 22.9 cm)

Comp.: 9½ × 7½ in. (24.1 × 19.1 cm)

This drawing and checklist no. 9 served as studies for the lithograph *Arch No. 2* and for the painting *Arch Hotel*.

9. *Sketchbook drawing, Paris*, 1928-1929 (Fig. 7b)

GRAPHITE ON PAPER

Sheet: 10⁹⁄₁₆ × 8¼ in. (irreg.) (26.8 × 21.0 cm)

Comp.: 5⅞ × 4⅜ in. (14.9 × 11.1 cm)

10. *Study for Arch No. 2*, 1928-1929 (Fig. 7c)

GRAPHITE, ORANGE CRAYON, AND GOUACHE ON PAPER

Sheet: 16⁹⁄₁₆ × 15⁷⁄₁₆ in. (42.1 × 39.2 cm)

Comp.: 9⁷⁄₁₆ × 13 in. (24 × 33 cm)

Inscribed, l.r. in graphite: "Stuart Davis"

11. *Study for Au Bon Coin*, 1928-1929 (Fig. 8a)

GRAPHITE ON PAPER

Sheet: 10⅝ × 8⅛ in. (irreg.) (27.0 × 20.6 cm)

Comp.: 5 × 5¹³⁄₁₆ in. (12.7 × 14.8 cm)

12. *Study for Hotel Café*, 1928-1929 (Fig. 4a)

GRAPHITE ON PAPER

Sheet: 12⅜ × 8¹¹⁄₁₆ in. (31.4 × 22.1 cm)

Comp.: 7½ × 5¹¹⁄₁₆ in. (irreg.) (19.1 × 14.5 cm)

13. *Study for Rue de l'Echaudé*, 1928-1929 (Fig. 12a)

GRAPHITE ON PAPER

Sheet: 9 × 12⁵⁄₁₆ in. (22.9 × 31.3 cm)

Comp.: 6⅞ × 11¼ in. (17.5 × 28.6 cm)

14. *Study for Theatre on the Beach*, 1928-1929 (Fig. 16b)

GRAPHITE ON PAPER

Sheet: 7¹⁄₁₆ × 8¼ in. (17.9 × 21 cm)

Comp.: 5⁵⁄₁₆ × 4⁵⁄₁₆ in. (13.5 × 11 cm)

Inscribed, u.r.: "L'Atelier"

15. *Study for Theatre on the Beach*, 1931 (Fig. 16a)

GRAPHITE, ORANGE CRAYON, AND GREEN CRAYON ON PAPER

Sheet: 17¹³⁄₁₆ × 23¹⁵⁄₁₆ in. (45.3 × 60.8 cm)

Comp.: 11 × 15 in. (27.9 × 38.1 cm)

16. *Study for Two Figures and El*, 1931 (Fig. 17a)

GRAPHITE ON PAPER

Sheet: 17¹⁵⁄₁₆ × 23¹⁵⁄₁₆ in. (45.6 × 60.8 cm)

Comp.: 11¹⁄₁₆ × 15 in. (28.1 × 38.1 cm)

Inscribed, u.l. in graphite: "11 × 15"

17. *Study for Bass Rocks*, 1938 (Fig. 23a)

INK ON PAPER

Sheet: 7⅜ × 9¾ in. (18.7 × 24.8 cm)

Comp.: 7¼ × 9⅜ in. (18.4 × 23.9 cm)

Inscribed, u.l.: "8/31/38"

PAINTINGS

18. *Blue Café*, 1928 (Fig. 8b)

OIL ON CANVAS

18⅛ × 21⅝ in. (46.0 × 54.9 cm)

Inscribed, u.r.: "Stuart Davis"

The Phillips Collection, Washington, D.C.

19. *Place Pasdeloup*, 1928 (Fig. 11a)

OIL ON CANVAS

36¼ × 28¾ in. (92.1 × 73.0 cm)

Inscribed, l.r.: "Stuart Davis"

Collection of Whitney Museum of American Art, New York; Gift of Gertrude Vanderbilt Whitney

20. *Place des Vosges No. 2*, 1928 (Fig. 3d)

OIL ON CANVAS

25⅝ × 36¼ in. (65.1 × 92.1 cm)

Inscribed, l.r.: "Stuart Davis"

Bequest of Helen Kroll Kramer; Dr. and Mrs. Milton Lurie Kramer Collection, Herbert F. Johnson Museum of Art, Cornell University

21. *Rue des Rats No. 2*, 1928 (Fig. 5b)

OIL AND SAND ON CANVAS

20 × 29 in. (50.8 × 73.7 cm)

Inscribed, l.l.: "Stuart Davis"; on stretcher u.r.: "Stuart Davis/Paris 1928"

Hirshhorn Museum and Sculpture Garden, Smithsonian Institution

22. *New York–Paris No. 2*, February 1931 (Fig. 9b)

OIL ON CANVAS

30¼ × 40¼ in. (76.8 × 102.2 cm)

Inscribed, on stretcher u.r.: "STUART DAVIS FEB. 1931"

Hamilton Easter Field Art Foundation Collection, Gift of Barn Gallery Associates, Inc., Ogunquit, Maine, 1979, Portland Museum of Art, Portland, Maine

23. *Bass Rocks No. 1*, 1939 (Fig. 23b)

OIL ON CANVAS

33⅛ × 43 in. (84.1 × 109.2 cm)

Inscribed, l.r.: "Stuart Davis 1939"

Courtesy Wichita Art Museum, the Roland P. Murdock Collection

24. *Midi*, 1954 (Fig. 20c)

OIL ON CANVAS

28 × 36¼ in. (71.1 × 92.1 cm)

Inscribed, l.c.: "Stuart Davis"; verso: "1954"

Wadsworth Atheneum, Hartford, Connecticut, The Henry Schnakenberg Fund

25. *Cliché*, 1955 (Fig. 24c)

OIL ON CANVAS

56¼ × 42 in. (142.9 × 106.7 cm)

Inscribed, u.l. "Stuart Davis"

Solomon R. Guggenheim Museum, New York

26. *Memo*, 1956 (Fig. 22d)

OIL ON CANVAS

36 × 28¼ in. (91.4 × 71.8 cm)

Inscribed, l.r. "Stuart Davis"

National Museum of American Art, Smithsonian Institution, Gift of The Sara Roby Foundation

SELECTIONS FROM DAVIS'S NOTEBOOKS AND SKETCHBOOKS, 1922-1938*

DAVIS'S LEGACY of paintings, drawings, and prints is enriched and illuminated by his extensive writings. Although his early art training with Robert Henri had contributed to an intuitive and experiential approach to painting, a confrontation with advanced European works in the Armory Show in 1913 opened his eyes to its ideational character and its philosophic tradition. From the early 1920s when he was striving to master the formal principles of cubism, Davis made thinking and writing the cornerstones of his systematic approach to the process of painting. In the selections that follow—writings that parallel Davis's experiments with compositional devices borrowed from synthetic cubism, his efforts to forge a style that would reflect his dedication to modernism and still express the realities of the American experience, and his efforts to persuade disbelievers on the right and the left that so-called abstract painting was genuinely relevant to daily life—certain concerns emerge repeatedly. Paramount among them is his insistence that painting has an objective, material reality of its own and that the first priority of the painter should be the establishment of that reality. In determining the best way to achieve this stated goal, Davis systematically examines the nature of the elements at his disposal. Whereas a discussion of the role of color dominates his writing in the 1920s, a new regard for drawing marks his notebooks and sketchbooks of 1931-1933. During this period, Davis came to regard drawing as the essential component of pictorial construction, and he developed a type of composition that stressed the importance of the angle as the basic structural element. It was between 1931 and 1932 that Davis produced a number of sketchbook drawings that later served as the point of departure for paintings, gouaches, and the WPA lithographs.

Davis's entry for July 6, 1938, written at a time when

*These excerpts, which appeared in Diane Kelder, ed., *Stuart Davis: A Documentary Monograph*, New York, Washington, and London: Praeger Publishers, 1971, were selected by and are reprinted with the editor's permission.

the artist was deeply involved in political activities in the American Artists Congress, restates his view that the material reality of abstract painting is linked with the natural environment and that the order of art is analogous to that of nature.

D.K.

NOTEBOOKS: 1922-1923

DECEMBER 30, 1922

A partial definition of a work of art might be,—an organization of units of a given medium which have a positive relation one to another which is satisfactory to the sense of equilibrium. This is quite apart from the subject that is carried by the organized unit. Needless to say works of art will be valued by different persons according to their respective temperaments so that all talk of a standard, except one of the most elastic nature, is out of the question.

The artist must, in order to produce his best work, be a conscious master of the medium in which he works. By means of this knowledge he is able to effect the translation of the image in his mind into the objectivity of his medium with economy of effort and is able to attain the maximum reality of his subject in that medium.

Every medium of expression has a life of its own which must be respected in order to get the best results. For this reason any expression which aims at actual reproduction of nature courts failure because in gaining a questionable illusion the actual life of the work, which is in the material out of which it is constructed, is lost sight of. In painting, paint, and in sculpture, stone, are the actual body of the work just as the body of human is made of flesh and blood and just at that point where the body of the work is sublimated to the idea beyond the sense perception of the observer it dies as a work of art. What this point is will differ with different tastes but that it exists is unquestionable.

Knowledge of the possibilities of the medium I would call technique, an entirely different quality than craftsmanship which is a matter of control of the hand. A man with a knowledge of technique in the sense in which I use it would be sure to produce works of some artistic value whereas a craftsman could be the best of his kind and still fail to produce a single work of artistic value.

The subject of a work of art may be of the most trivial nature or it may be of the highest moral and social significance but in either case it is of secondary importance from the standpoint of the artist.

I see all expression in terms of color. The word COLOR includes, AREA, PLANAL BALANCE, TEXTURE. A work is built by the superimposing of colored planes. For example in a black and white drawing the black line used is primarily a visual actuality because of its color. Secondly it has a certain area the size or extent of which is determined by the color of the paper, white. If you use black on a white paper you will use it in different areas than you would yellow even though in both cases you are expressing the same thing. In a word any graphic expression is the result of the use of color which in turn brings in the element of area which in turn involves the principle of third-dimensional balance. To go back, SUBJECT is nothing from the standpoint of the execution and yet it is the factor that starts the machinery of the execution to work. Consequently any subject is permissible though it be of no greater corporeality than abstract ideas but it will only be successful as a work of art if it submits to the above stated propositions for the reason that the above stated propositions are the flesh and bone through which the idea can have corporeal existence. The practical advantage to be gained from a recognition of these propositions is that the artist will see his inspirations immediately in terms of the medium in which he works and the result will be a clarity and precision that could not be gained in any other way. I believe that very few artists are aware of these facts and that most artists becoming conscious of them would find their work greatly improved.

The elements of color (which includes everything) that go to make up a painting must be correctly presented

according to the laws previously stated but their psychological effect on the spectator will only be effective when those color elements are the exact analogy of a sharply felt reality in the mind of the artist. Quite obviously the perceptions of the artist are foreign to most people, in fact it might be said that his audience is restricted automatically by the very quality that makes his work important, namely, its perception or appreciation of values overlooked by nearly everyone. In music, which is by its nature or perhaps merely through convention, abstract, the audience of the artist is larger than in painting—larger, but not really large. The thousands of people that yearly attend the concerts are made up of those who go to hear works that they and their ancestors have heard for generations. The elements common to all music, rhythm, harmony etc. are more readily felt by people in general than are the elements that go to make up a painting, but even at that as soon as a composer elects to use harmonies other than those in vogue for a hundred years his music is not performed at the big orchestral concerts until fifteen or twenty years after its conception when its novelties have become more or less familiar through various channels and even then it is usually met with laughter or anger by the audience, in accord with everything except appreciation. Art is never appreciated early or late except by a few people. The comparatively large body of persons who in some manner every year go out of their way to see or hear works of art are absolutely immune to its messages. Their appreciation of it is based on what some one who knows nothing about it has written [about it] or on the price paid for it or on some act of the artist which has been given newspaper space, on everything but genuine understanding. . . .

Intention is the motive power of achievement. Without the intention to do a certain thing it will never be accomplished. It is necessary to be as conscious of your goal as possible. A RATIONAL technique must be developed, meaning a technique that will achieve (when fired by intention) the particular kind of work that you regard as worth while.

There is PAINTING and there is DRAWING (their actual difference is really only one of weight, but for convenience we regard it as though they were separate functions). In making a drawing with black ink on a white paper the original surface is still dominant even after the drawing is finished. That is to say one has simply made some superficial scratches on the surface of a white plane without destroying the original strength of that plane. This is sound procedure but when it comes to the use of colors it becomes more complicated and as a result most paintings are bad. They are likely to start out well with a few simple color statements that are sound but when the process of elaboration starts the original statement is compromised and the picture has lost its chance of being good. The reason for this is perfectly clear and a recognition of it will enable the painter to avoid the prime departure from the laws of rational technique or common sense in other words. To begin with a painting is not a mystery, it is an object made from paint. The paint is the body of the picture and has a certain beauty in itself. This beauty in order to exist must not be tampered with too much, in other words the nearer a painting approaches to an actual illusion of the light of nature the more the primary and direct statement of the paint has of necessity been lost. It is necessary to recognize the limitations (physical not emotional) of the medium, to accept them and to make no effort to conceal them. A painting is made out of color which has certain inherent emotional properties and these colors by use in different proportions can be made to express an intended emotional message. That is the fact of painting. The painter has at hand a set of colors just as the musician has sounds and it is his business to compose in the material that he starts out to work with. It is because most painters do not do this that the average painting is so bad, not merely the difference in message but actual stupidity of technique even among those who are regarded as accomplished painters. To begin with we will say you start with a white canvas of a certain shape. By this selection an irrevocable step has been taken in regard to this particular picture. Every shape and color

used in this picture is now subject to your initial choice. In this sense we might say that the selection of the canvas is the most important thing about a painting. When your picture is finished the presence of the original canvas must be felt. If it is lost your picture will be bad just as though you built a tall house and after partial completion you started to remove the foundation, naturally the superstructure would fall down. The canvas is the foundation of the picture. Now, the analogy of the drawing in black on white, it is obvious that in a drawing in line that there will be more white paper showing in the aggregate than there is of the sum of the black lines. Here we have balance, THIRD-DIMENSIONAL BALANCE. In a word the superstructure of black lines does not obliterate the foundation which is the white paper. In the average painting on the other hand we have a complete obliteration of the original surface and a resultant awfulness. In water color there may be tremendous superstructure of planes (as in Cézanne) but, and here is all the difference, they are transparent and consequently of little weight, the white paper shows through them all. In oil painting, on the other hand, you are dealing in an opaque and heavy medium and the procedure is of necessity different. If it is used transparently one is not taking advantage of its inherent power and might as well work in water color. Oil painting [is a] heavier medium than water color just as a painted wooden relief is heavier than an oil painting and is the all important factor to be recognized. To draw the oval of a face with pencil on white paper and then to add with pencil the eyes, nose and mouth is one thing. To draw the same oval as a solid pink plane in oil paint, shade it and add the eyes, nose and mouth with a different color on a brush is something else. The innate sense of weight of the artist usually comes into play automatically in the first quick application of paint when he is sketching in his principle planes but when he begins to elaborate and to copy the subject in front of him with its shadows and variations that instinct is suspended and the result is we have a rotten picture. The instinct is sound but the desire for imitation of nature is stupid, and impossible. The phys-ical reality of your oil painting is simply some layers of paint, recognize this and make your effort to arrange in a perfect third-dimensional balance a few colors which have a positive emotional appeal symbolic of the emotion you feel at the time of painting. How that emotion is engendered in the artist is of no importance. He can get it by standing in front of a landscape, figure or still life or he can get it from his memory of one of those objects or it can be the result of a purly abstract idea. At all events it is the emotion that he is communicating in terms of paint and not the thing itself. The more the paint is allowed to retain its potential physical beauty the greater the strength of his statement will be. An oil painting must be composed of a series of superimposed colored planes whose aggregate weight is less than the base on which they are constructed. When a subject comes to your mind you must rationalize it in terms of oil paint and if you do this correctly you have given your emotion its maximum reality in the medium you have chosen.

MARCH 9, 1923

The effort of all painters is to shock the spectator by means of his color and design into reexperiencing the emotions that caused him to execute the painting. I am speaking of visual painting not illustration where the intention is to tell a story. The question naturally arises as to how to best express the emotion felt in paint. Up to date, the most successful method has been to copy the original stimulating object as closely as possible (the simplification that occurs in the type of work referred to does not run counter to the statement that the prime motive is to copy the original because the good imitationist painters have sense enough to allow for the limitations of the medium). It is now felt by many people however that this method of producing the sensation of reality has been developed to its utmost and that if we are again to experience visual pleasure in the medium of painting it must be in a different way. I believe I have arrived at such a method by the following logical process.

In the first place we must inquire what a painting really is and what are the mechanics of its emotional faculty. The answer is that a painting is composed of colors of different areas laid on a panel of certain size and shape. That is all there is and consequently the emotions that are felt on the contemplation of a certain painting must be the result of the combination of colors that the artist has put on the panel. Admit this and there quite obviously is no other course to follow than to work consciously in units of color of definitely related areas. My method demands that you divide the panel on which you are going to paint into certain subdivisions that are of visual value, for instance, on an oblong panel you might divide its length into four parts and its width into three parts, then you have a simple unit of proportion on which to base your areas. The emotion must then be interpreted in terms of color occupying a given proportion of the area of your panel and those proportions will all have a relationship easily appreciated by virtue of the common unit by which they are all measured. In the plan mentioned above all the colors will occupy areas which are either multiples or divisions of fourths or thirds. By this method it is possible for the artist to express himself completely in terms of the medium he has chosen and the result should be one of greater potential emotional power than a painting in which the artist made a series of compromises with his medium in his attempt to copy the exact values of a given local object. One method is a faint echo of the original stimulating object, while the other, better one is a frank translation of the original stimulating object into terms of the stimulating values of the medium of paint.

SKETCHBOOKS: 1932–1938

1932

The artist goes to nature to draw. In nature he sees a series of accidental combinations from which he selects. He is selecting accidents just as though he selects from a series of random lines on a piece of paper which have been drawn by himself.

This is the *subject* of painting. The mode of expression is by means of angular variation. From any given point the line moves in a two-dimensional space and is continually creating space relative to all existing points which is either expansive or contractive according to the point of observation. Relativity, knowledge of this fact, and the ability to visualize the logical correlatives of a given angle allows the artist to see the *real* angular value of his drawing as opposed to associative value.

A drawing or painting can only be understood physically by its arbitrary point relationships as determined by parallel coordinates. All drawings have point relationships. Yet some are good drawings and most are bad.

If point relationships were the only requirement to achieve interest, any random marks on a piece of paper would be interesting which we know they are not. Therefore there must be some particular kind of point relation which is good.

Study good drawings to find common point relation characteristics. If there is a type of point relation [that] is good as opposed to a type that is not good, then this knowledge can be used on nature itself. One can supply the points which are lacking in a natural scene which is uninteresting and make it alive.

Definitely understood are the ideas relating to drawing as follows: that anybody can *see* an interesting subject in nature. That none can draw it effectively. That a drawing is a real thing, equal to but *not* a replica of the subject in nature. That the anatomy of the drawing is *two dimensional*. That the *only* possible [thing] to be achieved in drawing is a numerical variety in the two-dimensional elements. The indivisible second unit is the triangle. The only possible optical fact is a change of direction which automatically creates a closed circuit, the [?] as any points on the two directions have continuous directional relation to each other.

Further, that there is a "specific" angular *contrast* which is fundamental to the most diverse subject matters (this

contrast constant may differ with different artists or different groups of artists but will remain the same to the same artist).

Optical interest is an intuitive observation of simply and clearly related rectangles. The observations can be drawn by drawing the rectangle itself or the diagonals or curves subtending one or more sides of the rectangle or the diagonals. The analysis of the intuitively perceived complex must be made in terms of one areal (angular) contrast at a time. When possible, let the rectangular principles assume associative shapes of common experience. Draw the co-ordinates not the natural deviations. . . . The objective of painting: to draw observed optical sensations in two-dimensional terms.

Therefore, our subject is not that which we see in front of us but a limited and arbitrary analysis in two dimensions. Therefore, if one says, "Why must I draw triangles etc., why do I have to visualize in these terms when they are not in the subject?," the answer is that they may not be in the subject but they are most emphatically in your painting. If an artist cannot visualize a simple geometrical relationship how can he pretend to a more complicated one. The answer is that he tries for complication through ignorance and gets a stupid result. . . .

On seeing an interesting scene in Nature, the artist has intuitively visualized a simple angular relationship. The vision has nothing to do with the specific objects that make up the scene and cannot be captured by copying those objects. The vision is a comprehensible angular complex and can only be understood in geometrical terms.

The optically agreeable is specifically related to simplicity of angular variation. This is not merely a phrase but a fact which can be comprehended and used to draw faultless pictures.

One constantly glimpses the character of the intuitive selections of scenes made in walking around. Their common denominator is analogous area which in turn is the result of angular simplicity.

The good picture is optical geometry. But more than, or rather through that geometry, the artist may express his sense of numerical variety. Which is a way of saying angular variation.

It is even possible to have a set formula for a good picture. The formula capable of adaptation to various associational ideas.

As in music, the blues, a set form, are always good and one might say that they express everything that can be expressed. A series of formula pictures carrying a sentimental association is possible and would be desirable.

The formula can only be arrived at through wholesale observation of nature and intellectual selection of the common denominator of varieties . . . which can be rationalized and used over and over again with success. It is of course not present in just any subject at all, but awareness of its character will allow the artist to see it when it is there.

July 6, 1938

Reality in art is composed of shapes and colors.

The artist must direct himself consciously to manipulate these objective elements.

Shapes and colors are of two kinds:

Objective	1. Local shapes and space shapes
and	
Subjective	2. Local colors and space colors

The sense of reality which the artist has only exists in terms of shapes and colors.

Then there is the geometric shape and color of the two-dimensional medium of painting itself.

The local and space shapes and colors of perception are evaluated in terms of the geometric shapes and colors of the medium of expression. Therefore, what the artist is concerned about is the observation and record of shape and color by means of an ideal shape and color scale.

The point must be made here that the observations of the artist are not concerned with the ideal shape and color scale but with the shapes and colors of objective and subjective experience.

Thus, the Meaning of art does not lie in the ideal scale even though it is always by manipulation of the scale that the expression of reality is achieved.

The meaningful positions of the geometric scale are only accomplished by first observing a position of local and space objects and colors to which the geometric shapes and colors are then made to correspond. (It should be noted here that sometimes an aimless manipulation of geometric elements may result in a meaningful design. But, again, it only becomes meaningful when it refers to something outside itself.)

It therefore becomes established that the artist is always drawing and composing shapes and colors which refer to natural environment. Recognition of this one point alone does away with a lot of mysticism about art. Then all of these local and space objects and colors have their ideological meaning too.

By ideological meaning I mean values other than physical, values having political, social, entertainment significance. This ideological content is present in all art. It is the "story" in the moral or didactic picture. It is the "mood" in the modern art of individual expression.

Art, then, is a triple unity of geometric form, objective form, and ideological form. With the knowledge of the reality and meaning of art the artist can approach his problem objectively. He can systematically record by going to nature without prejudice and selecting the shapes and colors of which its character is made. Second, he can consciously select the suitable objects associated with a purposeful idea and then construct them in their proper shapes and colors. Third, he can manipulate geometric space experimentally with the hope of finding new synthetic forms.

THE PRINTS OF STUART DAVIS:
A SELECTED BIBLIOGRAPHY

Adams, Clinton. *American Lithographers 1900-1960: The Artists and Their Printers*. Albuquerque: The University of New Mexico Press, 1983.

Carey, Frances, and Antony Griffiths. *American Prints 1879-1979*. Exh. Cat., London: The British Museum, 1980.

Charlot, Jean. *American Printmaking, 1913-1947*. Exh. Cat., New York: The Brooklyn Museum, 1947.

Field, Richard S., Sara D. Baughman, Debra N. Mancoff, Lora S. Urbanelli, and Rebecca Zurier. *American Prints 1900-1950: An Exhibition in Honor of the Donation of John P. Axelrod, B. A., 1968*. Exh. Cat., New Haven, CT: Yale University Art Gallery, 1983.

Flint, Janet. *George Miller and American Lithography*. Exh. Cat., Washington, D.C.: National Collection of Fine Arts, Smithsonian Institution, 1976.

——. *Prints for the People: Selections from New Deal Graphics Projects*. Exh. Cat., Washington, D.C.: National Collection of Fine Arts, Smithsonian Institution, 1979.

——. *Art for All, American Print Publishing between the Wars*. Exh. Cat., Washington, D.C.: National Museum of American Art, 1980.

Jacobwitz, Ellen S., and George H. Marcus. *American Graphics 1860-1940: Selected from the Collection of the Philadelphia Museum of Art*. Introduction by Alan Fern. Exh. Cat., Philadelphia: Philadephia Museum of Art, 1982.

Larson, Philip. "Five Cubist Prints." *The Print Collector's Newsletter* 7 (September-October 1976): 106-108.

Lipsky, Regina. *WPA/FAP Graphics*. Exh. Cat., Washington, D.C.: Smithsonian Institution Travelling Exhibition Service, 1976.

O'Connor, Francis V., ed. *The New Deal Art Projects, An Anthology of Memoirs*. Washington, D.C.: Smithsonian Institution Press, 1972.

——. *Art for the Millions: Essays from the 1930s by Artists and Administrators of the WPA Federal Art Project*. Greenwich, CT: New York Graphic Society, 1973.

Sims, Patterson. *Stuart Davis: A Concentration of Works from the Permanent Collection of the Whitney Museum of American Art*. Exh. Cat., New York: Whitney Museum of American Art, 1980.

Stuart Davis papers. Archives of American Art. Smithsonian Institution, Washington, D.C.

Stuart Davis: Prints and Related Works. Foreword by Diane

Kelder. Exh. Cat., Staten Island, NY: Staten Island Museum, 1980.

Wallen, Burr. *The Gloria and Donald B. Marron Collection of American Prints*. Exh. Cat., Santa Barbara, CA: University Art Museum, University of California, Santa Barbara, 1981.

————, and Donna Stein. *The Cubist Print*. Exh. Cat., Santa Barbara: University Art Museum, University of California, 1981.

Watrous, James. *American Printmaking: A Century of American Printmaking 1880-1980*. Madison: The University of Wisconsin Press, 1984.

Weber, Bruce. *Stuart Davis' New York*. Exh. Cat., West Palm Beach, FL: The Norton Gallery and School of Art, 1985.

Wilkin, Karen, and William C. Agee. *Stuart Davis (1892-1964): Black and White*. Dealer Cat., New York: Salander-O'Reilly Galleries, 1985.

Zurier, Rebecca. *Art for The Masses (1911-1917): A Radical Magazine and its Graphics*. Exh. Cat., New Haven, CT: Yale University Press, 1985.

THE FOLLOWING is a selected chronological listing of additional exhibitions in which Stuart Davis's prints appeared. Exhibition reviews that discuss Davis's prints are also cited. Edith Halpert of the Downtown Gallery represented Davis and his prints during his lifetime. Prints in the artist's estate have been handled by Associated American Artists and Sylvan Cole.

Exhibition of Work by Americans in Paris. New York: Downtown Gallery, October 7-28, 1928.
(Jewell, Edward Alden. "Art Galleries Offer a Rich Display," *New York Times*, October 14, 1928, Section 10, p. 13.)

American Print Makers Third Annual Exhibition. New York: Downtown Gallery, December 10-31, 1929.
(Cary, Elisabeth Luther. "Pre-Holiday Offerings in Art Galleries: Watercolors and Prints," *New York Times*, December 15, 1929, Section 10, p. 12.)

Catalogue of Engravings, Lithographs, and Etchings by American Artists. New York: The Weyhe Gallery, c. 1930.

First International Exhibition of Lithography and Wood Engraving. Chicago: Art Institute of Chicago, December 5, 1929–January 26, 1930.

Fifty Prints of the Year. New York: American Institute of Graphic Arts, 1930.
(Cary, Elisabeth Luther. "Fifty Prints of the Year and Other Art Events," *New York Times*, March 2, 1930, Section 10, p. 12; "Attractions in Various Galleries," *New York Sun*, March 8, 1930, p. 8.)

American Print Makers Fourth Annual Exhibition. New York: Downtown Gallery, December 8-31, 1930.
[Cary, Elisabeth Luther. "Etchings and Lithographs that Depict our Age," *New York Times*, December 14, 1930, Section 10, p. 18; "Attractions in Other Galleries, *New York Sun*, December 20, 1930, p. 9; "American Print Makers: The Downtown Gallery," *American Art News*, 29 (December 20, 1930): 59.]

Second International Exhibition of Lithography and Wood Engraving. Chicago: Art Institute of Chicago, December 4, 1930–January 25, 1931.

American Print Makers Fifth Annual Exhibition. New York: Downtown Gallery, December 7-31, 1931.
["American Print Makers: Downtown Gallery," *American Art News* 30 (December 12, 1931): 14; McBride, Henry. "American Etchers and Lithographers," *New York Sun*, December 12, 1931, p. 12; Cary, Elisabeth Luther. "The American Print Makers: Depth and Satire," *New York Times*, December 13, 1931, Section 8, p. 11.]

Exhibition of Fifty Modern Prints of 1932. New York: Weyhe Gallery, January 30–February 18, 1933.

American Print Makers Seventh Annual Exhibition. New York: Downtown Gallery, December 5-31, 1933.

American Master Prints. New York: Associated American Artists. nos. I (1968); II (November 1-27, 1971); III (March 25–April 18, 1974); V (October 11-30, 1976); VI (February 20–March 18, 1978); VII (March 17–April 22, 1981); VIII (1983); and other exhibitions c. 1968-present.

Fifth International Biennial of Contemporary Color Lithography. Cincinnati: The Cincinnati Art Museum, February 28–April 15, 1958.

Stuart Davis. New York: Associated American Artists, November 1-24, 1976.
[Russell, John. "The Prints of Stuart Davis," *New York Times,* November 19, 1976, Section C, p. 20; Urdang, Beth. "Stuart Davis," *Arts Magazine* 51 (November 1976): 6; Frank, Peter. "Stuart Davis (Associated American Artists)," *Art News* 76 (January 1977): 127-128.]

ADDITIONAL INFORMATION on Stuart Davis's life and work is contained in the following sources:

Arnason, H. H. *Stuart Davis.* Exh. Cat., Minneapolis: Walker Art Center, 1957.
———. *Stuart Davis Memorial Exhibition.* Exh. Cat., Washington, D.C.: National Collection of Fine Arts, 1965.
Goossen, E. C. *Stuart Davis.* New York: George Braziller, 1959.
Kelder, Diane, ed. *Stuart Davis: A Documentary Monograph.* New York, Washington, and London: Praeger Publishers, 1971.
Lane, John R. *Stuart Davis: Art and Art Theory.* Exh. Cat., New York: The Brooklyn Museum, 1978.
O'Doherty, Brian. *American Masters: The Voice and the Myth.* New York: Random House, 1973.
Sweeney, James Johnson. *Stuart Davis.* Exh. Cat., New York: Museum of Modern Art, 1945.

INDEX

Abstract Painting in America (1935), Whitney Museum exhibition, 11

Addison Gallery of American Art, Andover, Massachusetts (AGAA), 45

Adit, meaning of word, 24, 25n5

Adit, drawing (1928), 7, 29(2a), 80; print (1928), 7, 24, 25, 28

Adit No. 2 (1928), painting, 7, 29(2d), 80

American Artists Congress, 11, 84

American Artists School, 60, 61n2

American Institute of Graphic Arts, 25

American Print Makers Annual Exhibition, Downtown Gallery, 17, 25, 26n9, 51

Anchor (c. 1931-1932), drawing, 12, 63

Anchor (1936), print, 12, 60, 62

Arch Hotel (1929), painting, 8, 39(7d), 81(8)

Arch No. 1 (1929), print, 8, 24, 25, 26n9, 36, 81(6), 81(7)

Arch No. 2, drawing (1928-1929), 39(7c), 81(10); print (1929), 8, 24, 25, 26n9, 38, 81(6), 81(8)

Argument, The (c. 1915), print, 18

Armory Show (International Exhibition of Modern Art, 1913), 2-3, 23, 83

"Art for the Millions" (unpublished essay by Davis), 11-12

Art Front (journal), 11

Art Institute of Chicago, Chicago, Illinois (AIC), 30, 44, 52, 54

Artists Union, 11

Ashcan School, 3, 23

Atget, Eugène, 50, 57(16c)

Au Bon Coin, drawing (1928-1929), 7, 41(8a), 81; print (1929), 7, 24, 40

Ball State University Art Gallery, Muncie, Indiana (BALL), 66, 68

Baltimore Museum of Art, Baltimore, Maryland (BALT), 64, 68, 74

Barber Shop Chord, drawing (1931), 53(14b); print (1931), 10, 50, 51, 52

Barrére Wind Orchestra series, 61n3

Bass Rocks, drawings (1938), 74, 75(23a), 82; print (1941), 14, 72, 74

Bass Rocks No. 1 (1939), painting, 14, 72, 74, 75(23b), 82

Bass Rocks No. 2 (1939), painting, 74

Blips and Ifs (1963-1964), painting, vii, 15

Blue Café (1928), painting, 41(8b), 82

Braque, Georges, 4, 8

Breakfast Table (c. 1917), painting, 3

British Museum, London, England (BRIT), 54, 58

Brooklyn Museum, Brooklyn, New York (BROOK), 76

Buildings and Figures (c. 1931), gouache, 10, 55(15d)

Bull Durham (1921), painting, 4

Butler Institute of American Art, Youngstown, Ohio (BIAA), 32, 76

Cape Ann, Massachusetts, 72

Carnegie Institute, Museum of Art, Pittsburgh, Pennsylvania (CI), 28, 44, 45

Carrefour (n.d.), painting, 36, 81(7)

Cézanne, Paul, 3

Chine collé, Paris prints and, 25

Cincinnati Art Museum, Cincinnati, Ohio (CIN), 74, 76

Cleveland Museum of Art, Cleveland, Ohio (CLEVE), 32

Cliché, painting (1955), 72, 77(24c), 82

Collages, 4, 5

Colonial Cubism (1954), painting, 15

Colors of Spring in the Harbor (1939), gouache, 13, 65(20b)

Composition, tempera (1946), 13; print (1931), 10, 50, 59; print (1964), 15, 72, 73, 79

Contemporary American Painters series (Jack C. Rich), 14, 72, 73n1

Cook, Howard, 25

Cornell University, Herbert F. Johnson Museum of Art, Ithaca, New York (CORNELL), 58

Curry, John Steuart, 51

Davis, Edward Wyatt, 1-2

Davis, Roselle, 78

Davis, Stuart, death of, 15, 16; New Mexico trip of, 5; Paris trip of, 6-8, 23-25, 50; political activities of, 10-11, 84; printmaking ac-

tivities of, 7-10, 12-13, 15, 23-25, 50-51, 60-61, 72-73; writings of, 1, 11-12, 13, 83-89; *See also* Drawings by Stuart Davis; Paintings by Stuart Davis; Prints by Stuart Davis
De Kooning, Willem, 14
Dehn, Adolf, 25
Delaware Art Museum, Wilmington, Delaware (DAM), 74
Desjobert, Edmond, 25
Detail Study for Cliché (1957), drawing, 72; print, 15, 72, 76
Detroit Institute of Arts, Detroit, Michigan (DIA), 62, 64
Downtown Gallery, 10, 14, 17, 25, 26n10, 51, 72-73
Drawings by Stuart Davis
 Adit (1928), 7, 29(2a), 80
 Anchor (c. 1931-1932), 12, 63
 Arch No. 2 (1928-1929), 39(7c), 81(10)
 Au Bon Coin (1928-1929), 7, 41(8a), 81
 Barber Shop Chord (1931), 53(14b)
 Bass Rocks (1938), 74, 75(23a), 82
 Buildings and Figures (c. 1931), 10, 55(15d)
 Colors of Spring in the Harbor (1939), 13, 65(20b)
 Composition (1946), 13
 Detail Study for Cliché (1957), 72
 Gloucester Wharf (1926-1935), 51n1
 Harbor Landscape (1932), 13, 65(20a)
 Hotel Café (1928-1929), 7, 33(4a), 81
 Hotel de France (1928), 43(9a), 80
 Ivy League (1953), 73
 Landscape (1932), 13, 69(22b)
 Masses Back Cover (1913), 2
 New England Street (c. 1929), 10, 53(14a)
 New Jersey Landscape (c. 1931-1932), 67(21a)
 New York, 5, 10, 50
 Paris, 7, 8, 24
 Place des Vosges (1928), 7-8, 31(3b-c), 80
 Place Pasdeloup (1928), 8, 24, 47(11b), 80
 Porte St. Martin (1928-1929), 24, 81
 Rue de l'Echaudé (1928-1929), 48(12a), 81
 Rue des Rats (1928), 35(5a), 81
 Rue Descartes (1929), 8, 9
 Shapes of Landscape Space (1939), 13, 69(22a)
 Sixth Avenue El (c. 1931), 10, 50, 55(15c)

Street in Paris (1928), 7, 29(2b)
Study for a Drawing (1955), 72, 78
Theatre on the Beach (1928-1929), 10, 50, 57(16a-b), 81(14-15)
Thermos (1962), 73
Two Figures and El (1931), 10, 50, 58, 81

East Orange, New Jersey, 50
Eggbeater No. 2 (1927), painting, 6
Eggbeater No. 4 (1927-1928), painting, 6
Etching. See title of etching
Exhibition of Works by Americans in Paris (1928), Downtown Gallery, 25
Exhibitions. See name of exhibition

Federal Art Project (FAP), 7, 10-11, 12-13, 14
Fifty Prints of the Year, exhibition, American Institute of Graphic Arts, 25
Fitsch, Eugene C., 60
Foulke, Hazel, 2
Foulke, Helen Stuart, 1
Friedland, Jacob, 60
Funnel and Smoke. See Harbor Landscape

Gag, Wanda, 51
Gauguin, Paul, 3
Gentle, Esther, 73
Georgia Museum of Art, The University of Georgia, Athens, Georgia (GMA), 38, 42, 48
Gestalt theory, 14
Glackens, William, 2
Gloucester Wharf (1926-1935), gouache, 51n1
Gorky, Ashile, 51
Gottlieb, Harry, 60
Gouaches. See Drawings by Stuart Davis

Halpert, Edith. See Downtown Gallery
Harbor Landscape (1932), drawing, 65(20a)
Harbor Landscape (Funnel and Smoke) (1939), print, 13, 60, 64
Harvard University Art Museums, Fogg Art Museum, Cambridge, Massachusetts (FOGG), 34
Hayter, Stanley William, 26n8
Henri, Robert, 2, 3, 7, 11, 23, 83
High Museum of Art, Atlanta, Georgia (HIGH), 45, 58
Hirschl & Adler Galleries (New York), 9

Hirshhorn Museum and Sculpture Garden, Smithsonian Institution, Washington, D.C. (HMSG), 38
Hot Stillscape in Six Colors—7th Avenue Style (1940), painting, 6
Hot Stillscape in Six Colors—7th Avenue Style (Esther Gentle), silkscreen, 73
Hotel Café, drawing (1928-1929), 7, 8, 33(4a), 81; print (1928-1929), 7, 24, 26n9, 32
Hotel de France, drawing (1928), 43(9a), 80; painting (1928), 42; print (1929), 17, 24, 25, 26n9, 42
House and Street (1931), painting, 26n6

Indiana, Robert, 73
Indiana University Art Museum, Bloomington, Indiana (IUAM), 66
Indianapolis Museum of Art, Indianapolis, Indiana (IMA), 74
Industry (1928), painting, 7, 29(2c), 80
International Exhibition of Modern Art. See Armory Show
Iowa, University of: Museum of Art, Iowa City, (IOWA), 64
Ivy League, gouache (1953), 73; print (1953), 72, 73, 79

Kainen, Jacob, 12
Kelly, Ellsworth, 73
Kuniyoshi, Yasuo, 51, 60

Landscape, drawing (1932), 69(22b); painting (1932-1935), 13, 71(22e)
Landscape Space No. 4. See Shapes of Landscape Space (1939)
Lane, John, 1, 11, 14
Leger, Fernand, 5
Library of Congress, Washington, D.C. (LC), 28, 30, 54, 58, 62, 76
Lichtenstein, Roy, 73
Lithograph. See prints by Stuart Davis
Lowengrund, Margaret, 72
Lozowick, Louis, 25, 60
Lucky Strike (1921), painting, 4
Luks, George, 2

Marxism, 11
Masses Back Cover (1913), 2
Masses, The, 2, 23, 25, 25n1

Master Print series (Margaret Lowengrund), 72
Matisse, Henri, 3
Matulka, Jan, 24
McNay (Marion Koogler) Art Museum, San Antonio, Texas (MCNAY), 54
Memo (1956), painting, 13, 70(22d), 82
Metropolitan Museum of Art, New York (MET), 44, 64, 66, 76
Midi (1954), painting, 13, 65(20c), 82
Miller, George C., 10, 61n3
Miller, Richard, 72
Miró, Joan, 10
Monotypes, 7, 18, 23
Motherwell, Robert, 73
Multiple Views (1918), painting, 3-4, 8
Museum of Fine Arts, Boston, Massachusetts (MFAB), 58
Museum of Modern Art, New York (MOMA), 14, 32, 40, 45, 48, 49, 52, 54, 59

National Museum of American Art, Smithsonian Institution, Washington, D.C. (NMAA), 48, 52, 62, 64
New England Street (c. 1929), gouache, 10, 53(14a)
New Jersey Landscape, drawing (c. 1931-1932), 67(21a); print (1939), 13, 60, 66
New Mexican Landscape (1923), painting, vii, 5
New Mexico trip of Stuart Davis, 5
New School for Social Research, 14
New York City, Emergency Relief Bureau, 10
New York–Paris No. 2 (1931), painting, 8, 43(9b), 82
New York–Paris No. 3 (1931), painting, 8, 33(4b)
New York–Paris series (1930-1931), 4, 8. See also name of artwork
New York Public Library (NYPL), 45, 52, 66
Newark Museum (NEWARK), 7, 64, 66, 68
Norton Gallery of Art, West Palm Beach, Florida (NORTON), 36

Odol (1924), painting, 5
Oklahoma Art Center, Oklahoma City, Oklahoma (OAC), 52
Olds, Elizabeth, 60
Ortman, George, 73
Owh! In San Paō (1951), painting, 6

Pad No. 4 (Esther Gentle), silkscreen, 73
Paintings by Stuart Davis
 Adit No. 2 (1928), 7, 29(2d), 80
 Arch Hotel (1929), 8, 39(7d), 81(8)
 Bass Rocks No. 1 (1939), 14, 72, 75(23b), 82
 Bass Rocks No. 2 (1939), 74
 Blips and Ifs (1963-1964), vii, 15
 Blue Café (1928), 41(8b), 82
 Breakfast Table (c. 1917), 3
 Bull Durham (1921), 4
 Carrefour (n.d.), 36, 81(7)
 Cliché (1955), 72, 77(24c), 82
 Colonial Cubism (1954), 15
 Eggbeater No. 2 (1927), 6
 Eggbeater No. 4 (1927-1928), 6
 Hot Stillscape in Six Colors—7th Avenue Style (1940), 6
 Hotel de France (1928), 42
 House and Street (1931), 26n6
 Industry (1928), 7, 29(2c), 80
 Landscape (1932, 1935), 13, 71(22e)
 Lucky Strike (1921), 4
 Memo (1956), 13, 70(22d), 82
 Midi (1954), 13, 65(20c), 82
 Multiple Views (1918), 3-4, 8
 New Mexican Landscape (1923), vii, 5
 New York–Paris No. 2 (1931), 8, 43(9b), 82
 New York–Paris No. 3 (1931), 8, 33(4b)
 Odol (1924), 5
 Owh! In San Paō (1951), 6
 Percolator (1927), 6
 Place des Vosges No. 1 (1928), 6-7, 31(3e), 80
 Place des Vosges No. 2 (1928), 6-7, 31(3d), 80, 82
 Place Pasdeloup (1928), 6-7, 82
 Porte St. Martin (1928-1929), 36, 81
 President, The (1917), 3
 Ready to Wear (1955), 72, 77(24b)
 Red Cart (1932), 13, 67(21b)
 Rue de l'Echaudé (1929), 48
 Rue des Rats No. 1 (1928), 8, 34
 Rue des Rats No. 2 (1928), 8, 35(5b), 82
 Self-Portrait (1919), vii, 3
 Shapes of Landscape Space (1939), 13, 70(22c)
 Super Table (1925), 5
 Sweet Corporal (1922), 4

Tournos (1954), 13, 71(22f)
 Ultramarine (1943), 14
Paris trip of Stuart Davis (1928-1929), 6-8, 23-25, 50
Pasdeloup, De Jules-Etienne, 25n4
Pennsylvania Academy of the Fine Arts, Philadelphia, Pennsylvania (PAFA), 74
Pennsylvania State University, Museum of Art, University Park, Pennsylvania (PSU), 62
Percolator (1927), painting, 6
Philadelphia Museum of Art, Philadelphia, Pennsylvania (PMA), 52, 54, 64, 76
Phillips Collection, Washington, D.C. (PC), 30, 45
Picabia, Francis, 3
Picasso, Pablo, 3, 4, 5, 8, 10, 50, 51n3
Place Dancourt, Théâtre de Montmartre (Atget, 1925), 57(16c)
Place des Vosges, drawing (1928), 7-8, 31(3b-c), 80; photograph of, 30, 31(3a); print (1928), 7-8, 24, 30
Place des Vosges No. 1 (1928), painting, 6-7, 31(3e), 80
Place des Vosges No. 2 (1928), painting, 6-7, 31(3d), 80, 82
Place Pasdeloup, drawing (1928), 8, 24, 47(11b), 80; painting (1928), 6-7, 46, 82; photograph of, 47(11c)
Place Pasdeloup No. 1 (1929), print, 8, 24, 44
Place Pasdeloup No. 2 (1929), print, 8, 24, 26n9, 45
Political activities of Stuart Davis, 10-11, 84
Pollock, Jackson, 14
Poons, Larry, 73
Porte St. Martin, drawing (1928-1929), 24, 81; painting (1928-1929), 36, 81; photograph of, 37(6c)
Portland Art Museum, Portland, Maine (PAM), 74
Postage stamp, United States, 72, 77(24a)
Pratt-Contemporaries Graphic Art Center, 72
President, The (1917), painting, 3
Princeton University, The Art Museum, Princeton, New Jersey (PU), 66
Printmaking activities of Stuart Davis, 7-10, 12-13, 15, 23-25, 50-51, 60-61, 72-73. See also title of print
Prints by Stuart Davis
 Adit (1928), 7, 24, 25, 28

Anchor (1936), 12, 60, 62
Arch No. 1 (1929), 8, 24, 25, 26n9, 36, 81(6), 81(7)
Arch No. 2 (1929), 8, 24, 25, 26n9, 38, 81(6), 81(8)
Argument, The (c. 1915), 18
Au Bon Coin (1929), 7, 24, 40
Barber Shop Chord (1931), 10, 50, 51, 52
Bass Rocks (1941), 14, 72, 74
Composition (1931), 10, 50, 59
Composition (1964), 15, 72, 73, 79
Detail Study for Cliché (1957), 15, 72, 76
Harbor Landscape (1939), 13, 60, 64
Hotel Café (1928-1929), 7, 24, 26n9, 32
Hotel de France (1929), 17, 24, 25, 26n9, 42
Ivy League (1953), 72, 73, 79
New Jersey Landscape (1939), 13, 60, 66
Place des Vosges (1928), 7-8, 24, 30
Place Pasdeloup, 8, 24
Rue de l'Echaudé (1929), 24, 26n9, 48
Rue des Rats (1928-1929), 8, 25, 26n9, 34
Seventh Avenue (c. 1915), 18
Shapes of Landscape Space (1939), 13, 14, 60-61, 68
Sixth Avenue El (1931), 10, 50-51, 54
Study for a Drawing (1955), 72, 78
Theatre on the Beach (1931), 10, 50, 51, 56
Two Figures and El (1931), 10, 50, 51, 58
Two Heads (1929), 17, 25, 26n9, 49
Two Women (c. 1915), 7, 27
Public Works of Art Project. See Federal Art Project; Works Progress Administration

Ready to Wear (1955), painting, 72, 77(24b)
Red Cart (1932), painting, 13, 67(21b)
Refregier, Anton, 60
Reinhardt, Ad, 73
Report from Rockport (Esther Gentle), silkscreen, 73
Rhode Island School of Design, Providence, Rhode Island (RISD), 40, 49
Rich, Jack, 14, 72
Rochester, University of: Memorial Art Gallery, Rochester, New York (MEMR), 58
Rue de l'Echaudé, drawing (1928-1929), 48(12a), 81; painting (1929), 48; print (1929), 24, 26n9, 48

Rue des Rats, drawing (1928), 35(5a), 81; print (1928-1929), 8, 25, 26n9, 34
Rue des Rats No. 1 (1928), painting, 8, 34
Rue des Rats No. 2 (1928), painting, 8, 35(5b), 82
Rue Descartes (1929), gouache, 8, 9

Seine Cart. See New Jersey Landscape
Self-Portrait (1919), painting, vii, 3
Serigraph. See Prints by Stuart Davis
Seventh Avenue (c. 1915), print, 18
Shapes of Landscape Space, drawing (1932), 13, 69(22b); painting (1939), 13, 70(22c); print (1939), 13, 14, 60-61, 68
Sheldon Memorial Art Gallery, Lincoln, Nebraska (SHELDON), 36, 56, 64, 68, 76
Shinn, Everett, 2
Sillman, Si, 73
Singer, Arnold, 72
Siquieros, David Alfaro, 60
Sixth Avenue El, drawing (c. 1931), 10, 50, 55(15c); print (1931), 10, 50-51, 54
Sixth Avenue El No. 2. See Two Figures and El (1931)
Sketchbook drawings. See Drawings of Stuart Davis
Sloan, Helen Farr, 27
Sloan, John, 2, 7, 11, 23, 25, 25n1
Smith College Museum of Art, Northhampton, Massachusetts (SMITH), 76
Soyer, Raphael, 60
Spruance, Benton, 25
Stella, Frank, 73
Street in Paris (1928), gouache, 7, 29(2b)
Study for a Drawing (1955), print, 15, 72, 78
Super Table (1925), painting, 5
Sweet Corporal (1922), painting, 4

Ten Works/Ten Painters portfolio (Wadsworth Atheneum), 73
Theatre on the Beach, drawing (1928-1929, 1931), 10, 50, 57(16a-b), 81(14-15); print (1931), 10, 50, 51, 56
Thermos (1962), drawing, 73
Tiber Press, 72
Tournos (1954), painting, 13, 71(22f)
Two Figures and El, drawing (1931), 10, 50, 58, 81; print (1931), 10, 50, 51, 58

Two Heads (1929), print, 17, 25, 26n9, 49
Two Women (c. 1915), print, 7, 27

University Gallery, University of Delaware, Newark, Delaware (UD), 40
University of Kentucky Art Museum, Lexington, Kentucky (UKAM), 40, 52
Ultramarine (1943), painting, 14
University of Michigan, Museum of Art, Ann Arbor, Michigan (UMMA), 58, 62
University Art Museum, University of New Mexico, Albuquerque, New Mexico (UNM), 36, 45, 59, 62

Van Gogh, Vincent, 3
Vecchi, Floriano, 72

Wadsworth Atheneum, Hartford, Connecticut, 72, 73
Wagstaff, Samuel J., Jr., 73
Walker Art Center, Minneapolis, Minnesota (WALKER), 54, 76
Warhol, Andy, 73
Weber, Max, 51, 61n3
Wettling, George, 68
Whistler, James McNeill, 7
Whitney Museum of American Art, New York (WMAA), 11, 17, 30, 42, 48, 52, 54, 56, 58, 59
Whitney Studio Club, 10
Wisconsin Union, University of Wisconsin-Madison (UWM), 68
Works Progress Administration (WPA), 10-11, 12, 17, 60-61, 72. See also Federal Art Project
World's Fair (1939), 12
Wustum (Charles A.) Museum of Fine Arts, Racine, Wisconsin (CWMFA), 66

Yale University Art Gallery, New Haven, Connecticut (YALE), 58